First published in 2023 by
Search Press Limited
Wellwood, North Farm Road,
Tunbridge Wells, Kent TN2 3DR

ISBN: 978-1-78221-942-2
ebook ISBN: 978-1-78126-936-7

Suppliers

If you have difficulty in obtaining any of the materials and
equipment mentioned in this book, then please visit the
Search Press website for details of suppliers:
www.searchpress.com

You are invited to visit the author's website:
charlesevansart.com

Publishers' note

All the step-by-step photographs in this book feature the
author, Charles Evans. No models have been used.

Acknowledgements

Firstly, I'd like to thank Daler-Rowney for their continued support
and for supplying me with the best art materials imaginable. And
also, thank you to Beth Harwood, my editor, for making sense of it
all. She, despite our minor tiffs, always gets me there in the end.

Charles Evans'
WATERCOLOUR RESCUE

Top tips for correcting your mistakes and preventing them in the first place

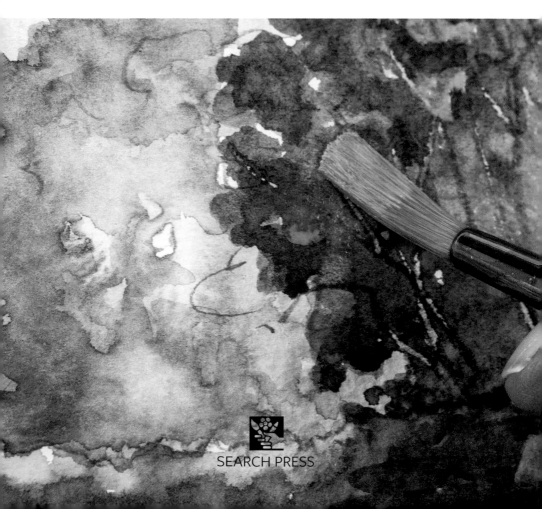

SEARCH PRESS

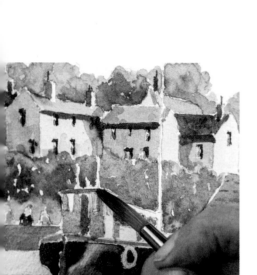

Dedication

This book is dedicated to Gail, who has been
one of my longstanding students
and basically inspired the book.

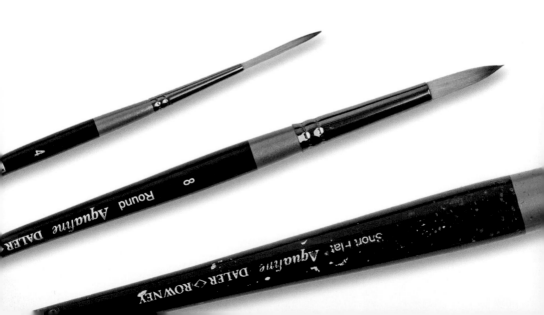

CONTENTS

INTRODUCTION

I have been teaching people to paint for about a hundred years and the same problems and questions have arisen time and again as each new class starts. Eventually, I realized the need for a first-aid book to help correct the common mistakes, and more importantly, stop them from happening again.

If it were possible to buy your painting kit and immediately sit down to paint a perfect picture, I would be out of a job! You wouldn't expect to buy a musical instrument and a sheet of music and then play a perfect tune, would you? You have to learn a new skill and the quickest way is by making mistakes. Even quicker is to learn from those mistakes with some expert and timely advice so that you don't make them again.

So the aim of this book is to help you understand why the mistake has happened, help you to correct it, then help you learn from your mistakes by offering you useful advice.

How to use this book

This book is not a step-by-step book, more a generalized guide to getting down on paper what you have in your mind. It's not designed to be read in one go, cover to cover, although you can do this; it's more for you to search through and locate your particular problem as you paint.

Where to get help...

...on choosing and using your tools and materials
Problems 1, 3, 4, 5, 6, 8, 10, 14 and 15

...on colour choice, colour mixing and water control
Problems 2, 26, 27, 28, 29, 30, 31, 33, 34, 37, 46, 48 and 54

...with your watercolour paper
Problems 7, 9, 11, 12 and 13

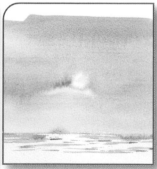

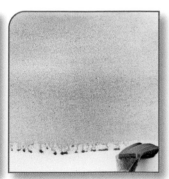

...with composition and sketching
Problems 22, 24, 25, 38, 39, 40, 44, 45, 49, 62, 63, 64 and 73

...with watercolour techniques
Problems 4, 5, 6, 8, 21, 42, 52, 59, 61 and 67

...with washes
Problems 15, 17, 18 and 27

...working with your watercolours

Problems 3, 20, 23, 28, 29 and 30

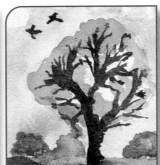

...achieving realism in nature

Problems 10, 16, 19, 32, 33, 34, 35, 36, 37, 38, 39, 40, 41, 42, 43, 44, 45, 46, 47, 48, 49, 50, 51, 52, 53, 54, 55, 56, 57, 58, 59, 60, 61, 69, 70 and 71

...achieving realism in buildings and man-made structures

Problems 38, 62, 63, 64, 65, 66, 67, 68, 69, 70 and 71

...with your finished painting

Problems 72, 73, 74 and 75

EQUIPMENT

Y ou don't need a lot of expensive materials to create successful watercolour paintings. This section will help you decide which equipment to choose to avoid becoming overwhelmed. It'll also explain the tools and materials you may need to rescue your paintings if things go awry, or that can help you to avoid mistakes in the first instance.

Think of your equipment as your first-aid kit!

I can never find the right brush

Experience has taught me that most people actually have too many brushes than too few to choose from. These days, there is almost a new brush for each different part of the picture! I stick with four classic sizes and styles of brushes. These are all Aquafine brushes by Daler Rowney; they are good and sturdy and hold lots of water.

They are: a 38mm (1½in) flat wash brush; a 19mm (¾in) flat wash brush; a number 8 round; and a number 4 rigger, for any fine detail.

I encourage you to practise with your brushes: use every part, every side and every angle, and you will discover just how many effects you can achieve with only four brushes.

38mm (1½in) flat wash brush
For large washes, such as for skies.

19mm (¾in) flat wash brush
For smaller washes as well as trees, grasses and lots of elements within the landscape.

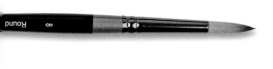

Number 8 round
This brush has a lovely, fine point with which you can do smaller detailed work; when pressed more firmly down onto the paper so that it spreads, it will give quite a wide coverage.

Number 4 rigger
For any fine details.

I can't decide which colours I need

There are so many different colours and tones of paint to buy. It's taken me many, many years to get down to the nine colours that I use every time. I find that with these, I can get every colour I need for my landscapes, wherever I may be in the world.

Too many colours in your palette can be very confusing; it's better to have fewer colours and experiment with mixing those colours. In addition, having too many colours in a palette with limited space can result in you wasting sometimes very expensive, paint.

Over the following pages, I show you how you can mix a range of greens and browns from no more than four tubes of paint

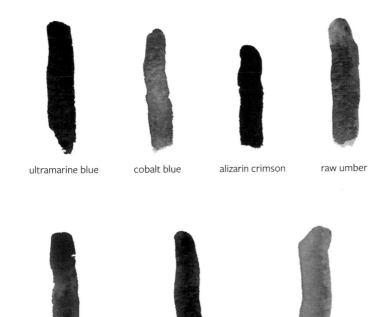

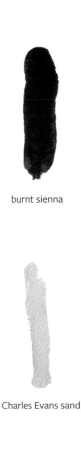

| ultramarine blue | cobalt blue | alizarin crimson | raw umber | burnt sienna |

| light red | Hooker's green | yellow ochre | Charles Evans sand |

Mixing greens

I have only one green in my palette, Hooker's green (see page 13). I always advise that you do not use it on its own if you're depicting a green in nature; rather, you should mix it with a lot of other colours in your palette to create many beautiful greens. By basing all your greens on Hooker's green, you will create harmony in your landscape paintings (see also page 71).

The mixes below all consist of Hooker's green mixed with the colours named, which are shown on the previous page.

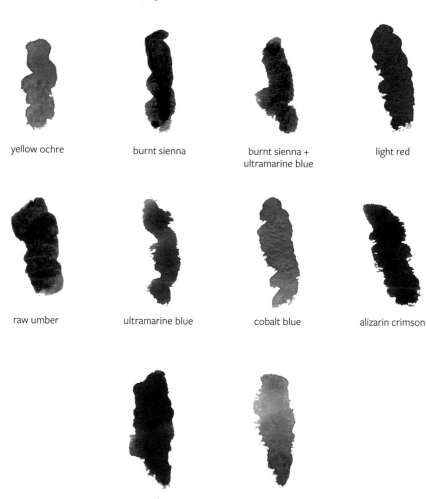

yellow ochre

burnt sienna

burnt sienna +
ultramarine blue

light red

raw umber

ultramarine blue

cobalt blue

alizarin crimson

alizarin crimson +
ultramarine blue

cobalt blue +
light red

Mixing browns

Raw umber is the only brown you need to buy: it can be used as the basis for four natural browns and mixes.

 If you add ultramarine blue to raw umber you can make sepia, and if you then add some burnt sienna to the mix you can make Vandyke brown. Adding burnt sienna to raw umber gives burnt umber – four browns from just one tube of paint!

raw umber on its own

raw umber + ultramarine blue = sepia

raw umber + burnt sienna + sepia = Vandyke brown

raw umber + burnt sienna = burnt umber

3. I can't decide whether I need students' or artists' quality paint

Although artists' quality paints are more expensive, I much prefer them to students' quality paints because the pigment is heavier and stronger, and you get a much more intense mix very quickly. With students' quality, you have to put nearly twice as much paint into the mix to get the same depth of colour, and, over time, your paintings will tend to fade much more quickly.

Artists' quality watercolours contain lots of natural pigment. They are stronger in consistency and stronger in colour as they go onto the paper.

The Daler-Rowney Aquafine paints – which I am using in this book – are, strictly speaking, students' quality paints, but the manufacturer has introduced some natural pigment into this range, which makes them much better than students' quality paints used to be. Nevertheless, they are always going to appear slightly weaker than artists' quality paint. A good artists' watercolour brand will always be more vibrant and have more strength, and also more staying power, than a less expensive brand.

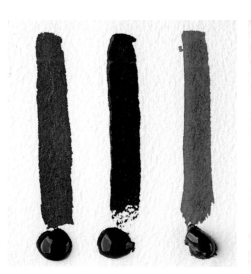 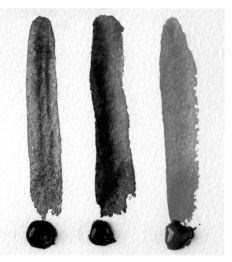

Artists' quality paint (L) versus students' quality paint (R)
Comparisons of ultramarine blue, alizarin crimson and Hooker's green in both paint qualities.

Masking fluid is latex (rubber) and it gets embedded in the fibres of the paper. The longer you leave it, the more embedded it gets as it dries. So, when you try to remove it, the masking fluid takes the paper with it.

If the paper is ripped, it is impossible to remedy as the surface of the paper is damaged. It is much better to use masking fluid in small areas at a time and remove it when that area is completed. I also thin the fluid with a little water so that the 'grip' is weaker.

How do I avoid it?

1. Don't apply masking fluid at the start of the painting and then take it all off at the end. Paint it on as and when you need it.

2. Paint over the masking fluid – in this case, with your sky wash.

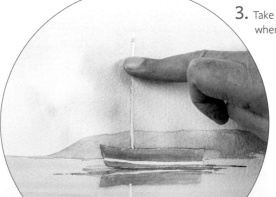

3. Take off the masking fluid when the area is finished.

5. I keep ruining brushes when I use masking fluid

The reason brushes are ruined by masking fluid is because masking fluid is latex (rubber) and it will clog every hair in your brush as it dries. Even after you have washed it out, there is no way you will remove all the fluid and when you come back to it, the brush will be solid and impossible to rescue. Follow the tips provided to protect your brush.

How do I avoid it?

Keep a little bar of soap handy (I spend a lot of time in hotels so they are always available). Wet the brush, then stroke over the bar of soap to get a lather. Go straight into the masking fluid with the brush.

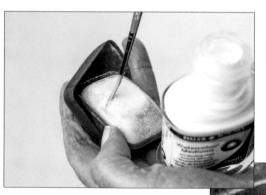

When you have finished with the masking fluid, rinse out the brush to take away the soap and the masking fluid with it, leaving a clean, unclogged brush.

Quite often the paper tears when I take the masking tape off

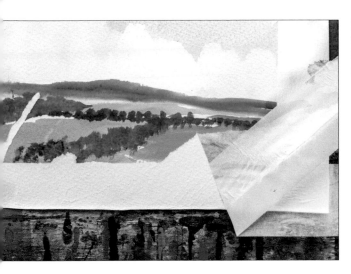

Don't use masking tape that is too tacky as it sticks too well to the paper and this causes it to pull away the surface.

How do I avoid it?

Masking tape can be safely removed by pulling it away from your painting at an angle. If it does rip the paper slightly, then it won't affect your picture. Angle the pull of the tape away from your painting, and use only low-tack tape.

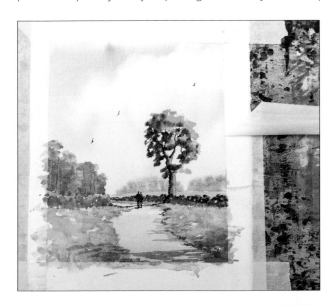

7. My practice paper wobbles and the surface comes off easily

Practice paper is, by virtue of its price, normally very thin paper and therefore won't stand much water. The sizing on the paper is also very thin and therefore comes off very easily. Although it's called practice paper, it will not give you the best result and you may be disheartened by the outcome. It's better to use good-quality paper every time and see your results improve!

The paper that I use, the Langton Rough, is internally sized, therefore the surface won't come off.

Sizing

Sizing, or size, is a treatment applied to watercolour paper. It enables the paper to absorb the pigment without it soaking it up completely and dulling it.

Notice the cockling on the practice paper surface, and the areas where the paint is flaking off.

This is a similar scene painted on decent-quality watercolour paper – none of the problems occur!

Look closely at, and compare, the surfaces of the unpainted practice paper, and the decent-quality watercolour paper, shown below.

Practice paper

Decent-quality watercolour paper

8. I have used a hairdryer to speed up drying and it has caused cockling

I never use a hairdryer as excessive heat can break down the sizing, leaving patchy areas.

If the hairdryer has caused cockling, then put the paper under a heavy object when it is dry (see page 27).

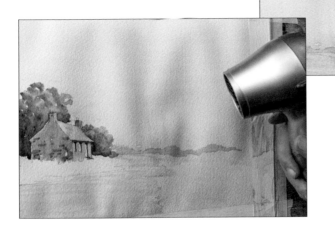

How do I avoid it?

If you need to wait for an area to dry, it is much better to leave it and have a cup of tea or, while one area is drying, paint elsewhere in the picture.

9. The surface of my watercolour paper seems to be rubbing off in bits

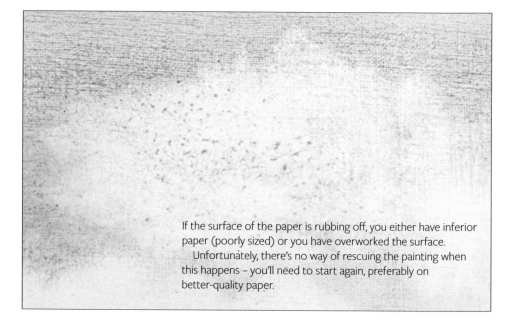

If the surface of the paper is rubbing off, you either have inferior paper (poorly sized) or you have overworked the surface.

Unfortunately, there's no way of rescuing the painting when this happens – you'll need to start again, preferably on better-quality paper.

How do I avoid it?

Buy a decent-quality watercolour paper of at least 300gsm (140lb) weight. You'll see from the photograph below that the surface will be superior to that of a cheaper paper (shown on page 20).

I'm using kitchen paper to make clouds and they don't look right

Kitchen paper is very absorbent and will suck the paint out all the way down to the paper, leaving clouds with sharp edges.

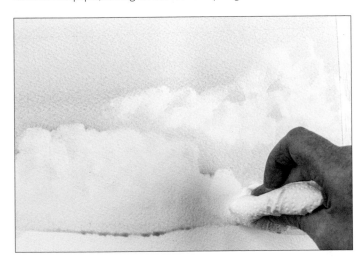

How do I avoid it?

It's much better to use a damp brush, which will give you a softer edge to the cloud. Do note, it should be a clean, damp brush, *not* dry. As I suck out the blue to form the clouds, I drop the blue on my brush back into the middle of the clouds for cloud shadows. Instantly you create movement, and the result is softer, more natural-looking clouds.

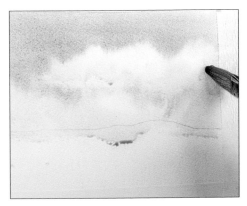

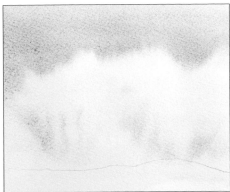

11. I can never decide which is the right side of the paper to paint on

If you aren't sure which is the right side of the paper to paint on, generally, it's the rougher side, where you can see the texture.

This sky has been painted on the 'wrong' side of the paper, and you'll notice that a lot of feathering has occurred, as well as cauliflowers (see page 49), which form more readily on an inadequate surface.

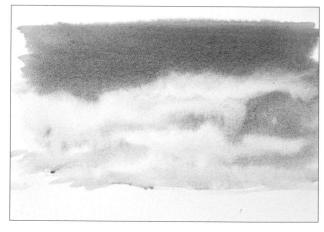

Painting on the 'wrong' side of the paper

The 'wrong'/reverse side of the paper

The right side of the paper

How do I avoid it?

Some cheaper papers are only sized on one side whereas the Langton Rough 300gsm (140lb) paper that I use is internally sized (see page 20) so both sides can be painted upon.

Look carefully at both sides or use an internally sized paper.

12. I've always been told to stretch the paper before painting. Why?

Personally, I never stretch paper: a decent-weight paper – 300gsm (140lb) and over – is never really going to give you any problems if left unstretched.

If you are using a lighter paper, however, you could stretch it first to ensure that it doesn't cockle. To do this, wet the underside of the watercolour paper and apply dampened brown tape along each edge, as shown below.

Stretching

Stretching watercolour paper, by soaking it with water before applying it to a solid surface, keeps the paper surface flat and taut, and prevents cockling or buckling and distortion of the painting.

As everything dries (overnight), the paper will be stretched taut – then you can start to paint.

When you have finished the painting, you will have to cut it off the surface. This is all a very fiddly process, which is easily avoided by spending a bit more money on a good-quality paper.

13. My paper keeps getting waterlogged

The culprit is likely to be the way in which you've attached your paper to your board or surface.

Don't attach your paper with masking tape in the four corners: your paper will not be secure and if you put a big wash on, the water will go underneath the paper and create beading as it seeps out from under the paper, or create water marks round the edges.

As the paint starts to dry out, you'll see what an uneven effect you get coming in from the sides of the paper as the water that is trapped behind the paper seeps round.

Sometimes if you've gone in too heavily with a particular colour, that also gets trapped and as it dries out, strong colour seeps into the picture.

All of this results in the paper buckling, or cockling.

Put the painting face-down on a table and place a couple of books on top to flatten the paper and even out the cockling. Leave for a few hours or overnight.

The paper, after having been flattened.

How do I avoid it?

Make sure that you tape all the way round all four sides. This way, your paper won't move, your edges will be protected and you will have a nice white border when you take the tape off.

Remember, always pull the tape off moving away from your painting, to avoid damage to your masterpiece (see page 19).

My pencil lines keep smudging

It's likely that you're using too soft a pencil. Also, if you're moving around different parts of your drawing to complete it and not working logically, you risk smudging the lines you've already drawn.

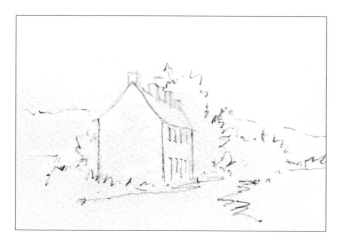

How do I avoid it?

Plan your drawing so that you are working downwards from the top thus avoiding putting your hand over already drawn areas. Also, when you put a wash on, this can naturally smudge the pencil line. To avoid this happening, use an HB pencil and light lines – avoid using a soft pencil such as a B for sketches.

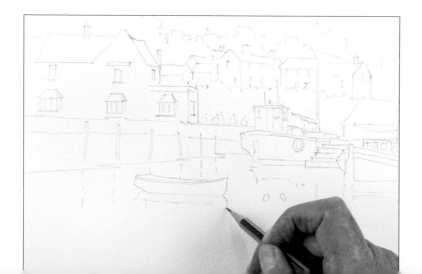

I can't get an even wash with watercolour pencils

The main mistakes people make are when doing a sky wash – they draw on it and then wet it and expect a sky but get only lines.

How do I avoid it?

1. Take the paint off the pencil with a damp brush.

2. Paint the pencil pigment onto the paper.

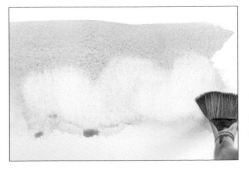

3. Treat the pencil pigment as if you were applying a watercolour paint wash, and lift out any clouds with a clean, damp brush.

My objects look flat in watercolour pencil

In the case of a tree trunk, for example, hard, sharp edges between colours are going to look flat as opposed to rounded and more natural.

Using two colours, as shown on the right, will not give you enough variety in tone to give your object shape and dimension.

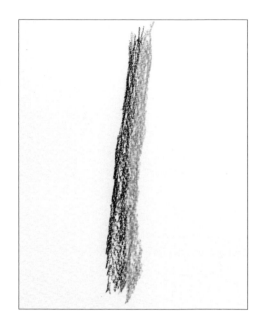

How do I avoid it?

The solution to this, to give a nice, rounded effect to your tree trunk, is to use three colours, bleed them gradually on the paper, and merge them, from light, to mid-tone, to dark. This will result in a much more natural, rounded-looking trunk.

I have used dark grey, golden ochre and dark sepia for this example.

Initially my tree looks like a stick of rock until the water performs its magic – see opposite.

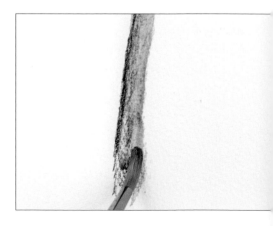

Using a number 8 round brush, stroke over the pencil marks, softening and merging the colours.

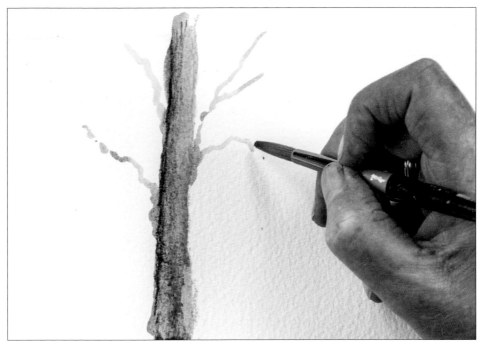

While the watercolour pencil is still wet, using the merged colours on your brush, move the colour around, picking up paint to create boughs and twigs coming out of the sides of the trunk, to further shape the tree.

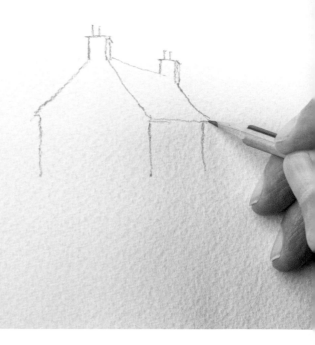

TECHNIQUES AND COMPOSITION

The aim of this chapter is to pass on some of the many tips and techniques that I have amassed over many years of painting. Some of the effects and techniques within a watercolour painting can be quite difficult to achieve, but if there is an easier way of doing something that I can pass on to you, then it is probably included here.

Likewise, if there are any easy fixes that can be applied when a technique goes wrong, I will share these with you too.

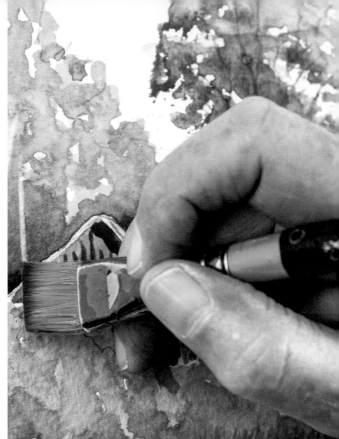

17. My graduated wash isn't graduated!

A bad graduated wash is the same colour and tone all the way down instead of getting weaker, and lines can appear if you don't paint into your last stroke.

Once the wash is completely dry, reapply the wash, making sure it's at least twice the strength of the original. Start at the top and let the original wash show through more as you work downwards; dilute the paint more as you work, to weaken the colour on your brush.

How do I avoid it?

Always pre-wet the paper and have your board on a slope (about 30 degrees). This allows the water to run downwards, thinning the paint as it comes further down. Start at the top and paint into your last stroke as you come down to avoid lines and let each stroke blend into the next. Also have your paint well watered so that it will flow easily down over the paper.

My flat wash isn't flat!

Basically, what you are doing is creating a bad graduated wash. A flat wash should be the same solid colour all the way down, which is achieved by keeping the board flat and making sure that your colour is at the same strength for each stroke.

To rectify, add more of the colour and repeat the process with straight, even strokes of paint.

How do I avoid it?

To paint a flat wash correctly, remember that a flat wash is defined by even colour. Make sure that there is plenty of water on the paper and the paint needs to be a good, even flow throughout the wash.

My white clouds keep turning out blue

It's likely you are leaving too much colour on the paper when taking out. It always helps to make your clouds look whiter and lighter if the blue of your sky is stronger because this creates greater contrast.

You can be fairly hard on the paper with the brush: use a damp brush to take out the paint.

How do I avoid it?

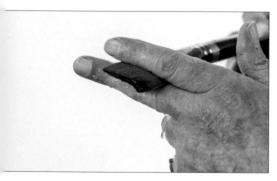

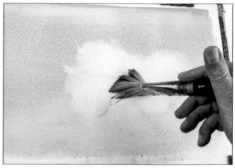

1. To correct your blue clouds, take out with a damp brush – squeeze the brush between your fingers first to remove any excess moisture. A damp brush is more effective than a dry brush. One squeeze will take out enough water to leave you with a sufficiently damp brush.

2. Lift out the colour, applying pressure using the side of the brush – this is more effective than using the tip.

As you are taking out the clouds, you must always be washing and squeezing out the brush. In this way, you are taking out paint, not just moving it around.

20. I can't seem to soften colours together and get rid of hard edges

You haven't painted the colours quickly enough to bleed into each other.

Rectify this by going back over the harsh edges with a wet or damp brush, encouraging the colours to bleed and soften. You can do this on paintings that have been left to dry for months – it is never too late to correct a problem like this.

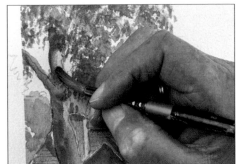

How do I avoid it?

Avoid harsh edges between colours by making sure all colours stay damp so that they do blend together.

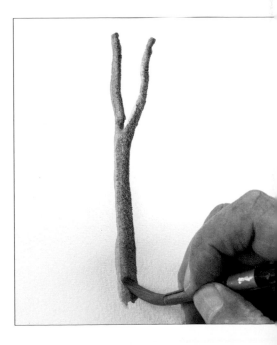

I've forgotten to leave white paper for a detail

Maybe you didn't plan ahead and accidentally painted through an area that you wanted to leave white. This can be rectified in lots of cases by washing out with the brush, in this case a 19mm (¾in) flat; squeeze and sharpen the brush between your fingers then suck out the paint (such as for a tree trunk). You can suck out as many times as you want as long as you wash and squeeze out your brush between strokes.

You can reinstate the white paper by simply removing the paint. Even if a painting has been left to dry for months, this technique will still work – there is no time limit to when you can go back and take out the colour.

To put in some tree trunks on the left of this scene, for example, go in with the sharp tip of your dampened brush and lift out the paint to reintroduce light.

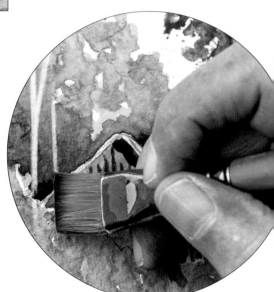

How do I avoid it?

Pre-plan – make a sketch first so you have a better idea of where the light will need to be and where the white of the paper will need to be preserved.

Alternatively...

You can add some strong contrast by placing a dark next to where the light area needs to be.

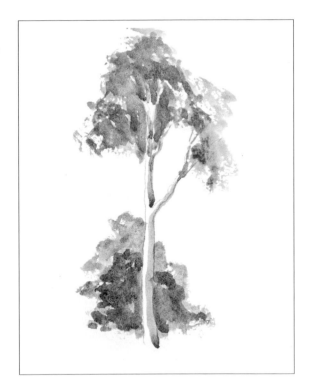

The contrast of dark next to light gives the suggestion of light and the white of the paper without you having to remove any paint.

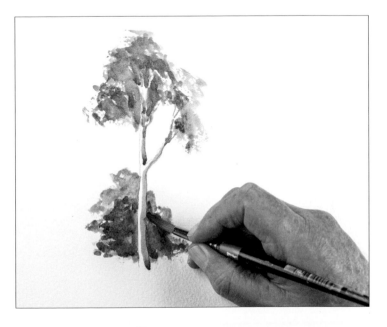

22.

I'm daunted by clean, white paper and don't know where to start

So many novice artists find a glaring white sheet of paper very daunting. The main worry is where to start but this will dissipate once you get paint on the paper.

You will find that once you've got a sky wash on, which – in the case of many landscapes – occupies two-thirds of your paper, you can then put your drawing on top of it when it has dried.

Similarly, in some cases, I have seen people pre-stain the whole surface of the paper with a very weak wash. In this case I would normally use yellow ochre or raw sienna.

You don't need to pre-wet the paper; just go in with very wet paint on a large brush, and tint the paper. Leave to dry – it may need to be left overnight.

Once your pre-stained paper is dry, you can sketch over it.

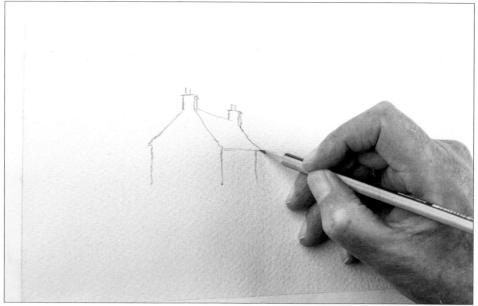

23. I can't make sense of working from light to dark

If you paint a light colour on top of a dark colour in watercolour, it won't show. You can only paint a dark colour on top of a light colour.

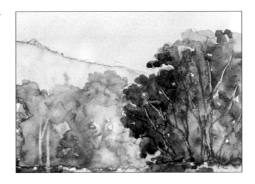

How do I avoid it?

It is best to pre-plan how you want to paint an area and always paint the light colours first. For example, in the case of foliage in trees, I always paint yellow ochre on first and build up the darker colours around this.

Alternatively...

If it's too late and you can't resolve the problem, you can always turn to a little bit of gouache (below), which is a totally opaque watercolour, and will show as light on top of dark (below, right).

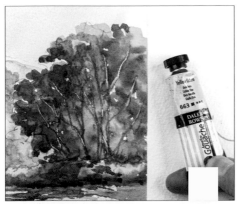 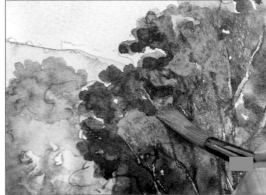

24. The more I try to get the picture right, the worse it looks

Sometimes you realize that the picture isn't how you envisioned it. *Stay calm, don't panic.* Nothing is worse than too much fiddling and overworking the area. If you do this, there is no going back.

In the example on the right, the bushes in the foreground have been overworked and now distract from the subject of the painting – the Château at Pierrefonds, France.

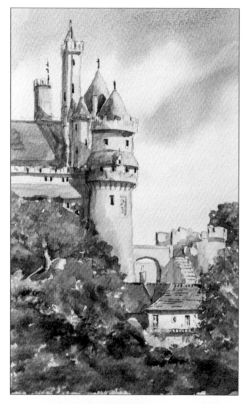

Instead, let the painting dry completely, then wash out any messy bits you don't like with a clean, damp brush and let it dry again. Then either repaint the detail or, in the case of a landscape, add a few bushes or trees over the areas that you don't like.

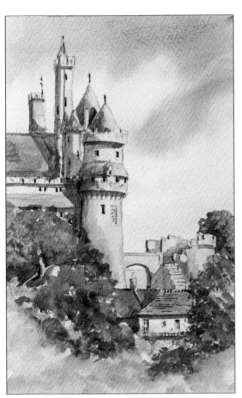

The corrected painting, with balance restored between the foreground and background.

How do I avoid it?

Remember that the foreground doesn't have to be the most detailed part of the painting. However, more often than not, it has to be the *strongest* part of the picture as it's the nearest to the viewer. A painting is much like a good book – it has a beginning, a middle and an end. In this case, the beginning or the foremost part is the strongest but not necessarily the most detailed, otherwise you will take the eye away from the rest of the picture.

Consider where the focus of your painting is, and apply your details accordingly.

My picture looks unbalanced somehow

You have to decide, if it looks unbalanced, what it is about the picture that is wrong. When you do the original drawing for the painting, your pencil lines should tell you if the picture will be unbalanced or not, before you start painting. Take a good long look at your drawing because at this stage it is easy to rectify any mistakes just by rubbing out.

In the sketch on the right, there is no variation in depth or distance; the trees and the path are all on the same plane – the horizon line runs through the bottom of the trees and the top of the path.

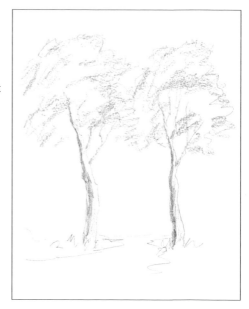

How do I avoid it?

Lots of people treat the Rule of Thirds (see opposite) as gospel, and in workshops I've even seen people using rulers to divide their paper into thirds, with mathematical precision. Remember, this is art, not maths!

It is, however, important to ensure that the horizon line is not right in the middle of the paper, as this will split your painting in half. Keep your horizon line above, or below, halfway, and that will give your composition the necessary balance.

In the sketch on the right, the horizon line is still at the bottom of the composition, but the trees and the path have been placed around – not right on – the horizon line, adding balance to the scene.

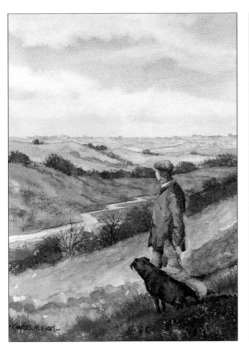

Surveying the Vista

What is the Rule of Thirds anyway?

The Rule of Thirds determines that a painting will have balance if it is broken down into visible 'thirds'. For example, one-third of the composition will be sky and two-thirds land, or two-thirds sky and one-third land, as in the examples shown on this page.

In the top painting, 'Surveying the Vista', there is predominantly more land featured in the composition, and the horizon line is above the halfway mark. In the painting below, 'Druridge Bay', you can clearly see the difference — the sunset sky is dominant in this composition and the horizon is below halfway down the paper.

It's a useful rule to keep in mind, but remember not to get bogged down measuring the paper — it's not an exact science!

Druridge Bay

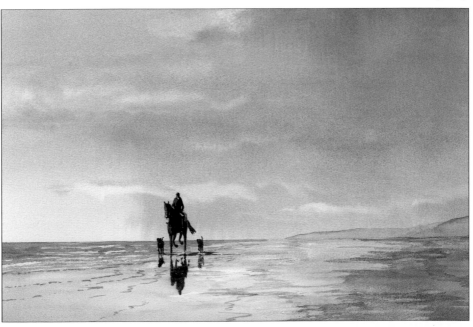

COLOUR MIXING AND WATER CONTROL

I t is useful to know how to mix the colours you want, and how to adjust them once they are on the paper. To avoid mistakes, always test your mix on a piece of scrap paper first, and allow for the fact that watercolour always dries lighter than it appears in your palette.

You may wish to alter a colour once it is on the paper. For example, you might want to remove some colour in order to introduce light into a painting, or change the colour of a sky. In this chapter of the book, I show you how to rescue a colour that may be too dark or light, and how to remedy water splashes and cauliflowers without having to start your painting over again.

26. I've accidentally dropped water on the picture and ruined it

Don't worry: even a large splash can be remedied.

Wait until the splash has fully dried, to avoid bleeding in, and then reinstate the colours (as shown below).

When you reinstate the colours due to your splash, make the colour mix slightly stronger than the original so that you can merge and soften in either side of the splash. This way, it becomes part of the overall picture rather than paint over the splash area.

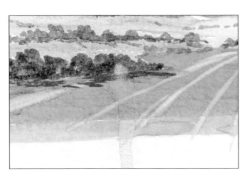 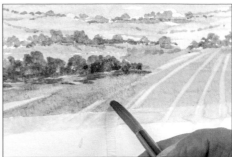

How do I avoid it?

First of all, to avoid problems like this happening, make sure your painting space is organized properly. For example, don't have your water container too close to the board to avoid knocking the container over and splashing water on the painting.

Also, don't have the water container on the wrong side of the board. By this, I mean have the water container on the same side as your painting hand so that you are not dipping your brush into the water and then carrying this across the painting. Both of these might sound obvious, but you'd be amazed at how often I have seen these accidents happen.

27. I get cauliflowers, especially when I'm painting sky washes

Most of the time, a cauliflower, or runback, occurs when you have waited that bit too long and the wash is staring to dry. Then you go in with a wet brush and the water spreads into the damp area taking the pigment with it, causing a cauliflower.

Have the area finished while it is all still wet or wait until it is completely dry. Don't mess about at the damp stage.

To correct, let the whole thing dry first. If still wet, you'll overwork the surface of the paper and make the cauliflower bigger.

Re-wet as if starting again where the cauliflower is harshest. Applying pressure to the side of your brush, work into the cauliflower.

How do I avoid it?

When you start your sky wash with a pre-wet, it still needs to be wet when the sky is finished. So, paint the sky fairly quickly and don't fiddle about with it too much because, on most occasions, a cauliflower occurs when you are going back in to a nearly dry piece of paper with a damp brush.

The cauliflower has been lifted out, and your sky wash has been rescued!

One colour is bleeding into another

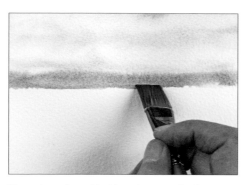

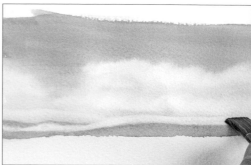

The colours have bled here because I've begun to paint the hills before the sky has dried sufficiently – see how the colour from the top of the hills is bleeding into the sky.

Go in with the sharp edge of a clean, damp brush: remove the colours that are bleeding, all while still damp.

If you want to re-establish the top of the hill, wait until the whole painting is dry then go back in with the same colour so that you've rectified the problem. With a clean, damp brush, stroke the colour up and over the line again.

How do I avoid it?

To prevent this in the future, make sure that the previous wash area is dry before you go in with the next colour.

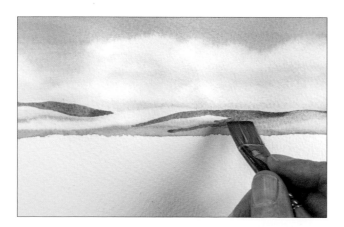

My colours/mixes are too thick

Believe it or not, I've seen people use watercolour from the tube straight onto the paper with no water added. Watercolours are precisely that: they need water added into the colour.

The eternal question is – how much or how little water do I add? This worries a lot of people.

Remember, this is watercolour – you need transparency, so if, when you put it on the paper, it looks too thick, add more water either into the palette or, at this stage, put more water into the mix on the paper.

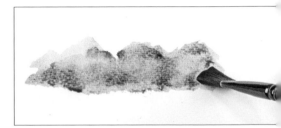

How do I avoid it?

When you're making your mix, remember that you need enough water to make the paint flow but not so much that it gets too watery. Add enough water to get a flow with the intensity you are looking for.

Dip into the colour with the brush and pull the paint into your mixing area. Then put two brushfuls of water into the mix.

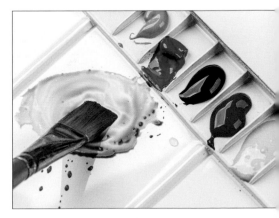

My colours/mixes are too weak and watery

I've seen this done so many times in workshops! What tends to happen when people are mixing two colours is that they flood the mixing area with too much water. Then they wet their brush again, go into the first colour and mix it in. Then they wash out the brush, add more water to the second colour and mix that in, and end up with an insipid, weak mix.

In the example below, I've mixed Hooker's green and burnt sienna.

 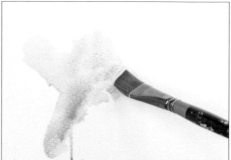

How do I avoid it?

Mix your two chosen colours to the shade that you want, *then* add a little bit of water.

If the resultant colour had come in a tube, pre-mixed, you wouldn't squeeze it out and water it down numerous times: you'd only water it down once. So, make the colour *then* add water.

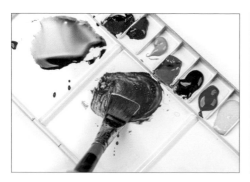 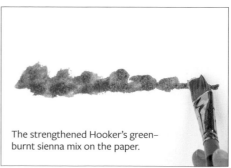

The strengthened Hooker's green–burnt sienna mix on the paper.

I keep mixing muddy colours

Some mixes of three colours will make mud, and browns and greens are a prime example of this. When I say 'mud', I mean it's neither one colour nor the other – and it's not very pretty!

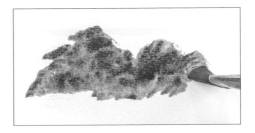

How do I avoid it?

There are occasions when three colours will mix together to form a clean, new colour, as in my shadow colour, right, which is a mix of ultramarine blue, burnt sienna and alizarin crimson.

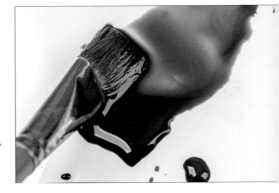

If you want to darken an area already painted, such as foliage, rather than mixing three colours in the first instance, mix two, then add a separate, darker colour to the paper on top of the existing mix (as shown below).

Generally, you should stick to mixing just two colours. If you've mixed mud, wash the mix from your palette and start again.

32. I've painted a sky too dark

What you have to bear in mind when painting a sky wash (after first pre-wetting the area) is that, with any watercolour, it is going to dry about 30% lighter than when wet. However, if you overcompensate for this, your sky can come out too dark. Paint a small sample on your paper and see what it looks like when it is dry.

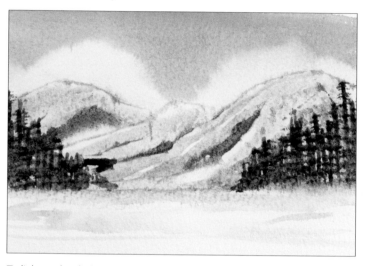

To lighten the sky in a picture, turn the painting upside-down first then re-wet the area. This allows the paint to run towards the top edge of the painting, keeping the bottom part untouched. Lift out the excess colour with a clean, damp brush.

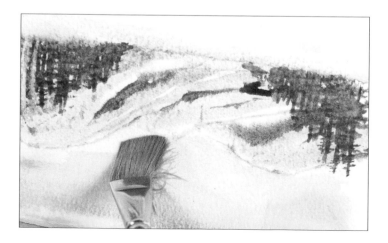

How do I avoid it?

If you want a dark sky, make the mix dark but ensure that it is still running on the paper, and is not too stiff a mix.

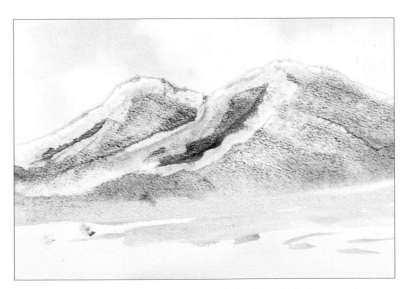

The result will be a sky that contrasts perfectly with the objects in the foreground.

When I use black paint, it seems to kill the picture

A manufactured black, to my mind, is flat and dead.

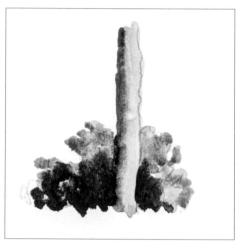

If you have used a manufactured black, dab the area with a damp brush to lessen its impact, which will correct it to a degree.

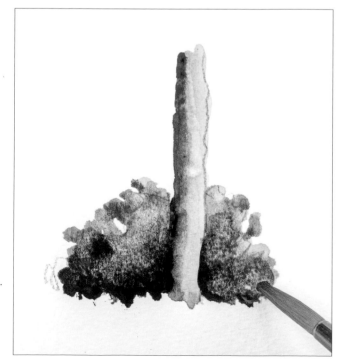

The muted black area.

How do I avoid it?

Don't use a manufactured black; use a mix, either using ultramarine blue and burnt sienna (as below), or Hooker's green and alizarin crimson.

You can more easily weaken your own mix too, if necessary, for a faint shadow, as shown below.

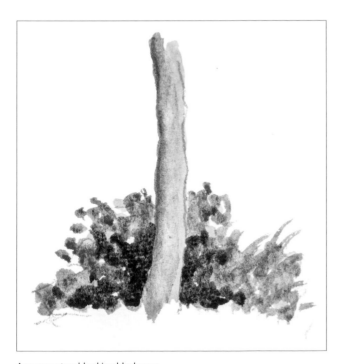

A more natural-looking black area.

I don't know how to mix browns

The brown mix shown on the right is very wishy-washy and doesn't particularly look like a natural brown.

See page 15 for guidance on mixing several natural browns.

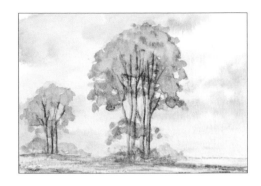

How do I avoid it?

Replace that yucky unnatural brown with a raw umber–burnt sienna mix, shown below, to make a burnt umber, and a raw umber–ultramarine blue mix for a sepia (opposite).

Applying the burnt umber mix of raw umber and burnt sienna.

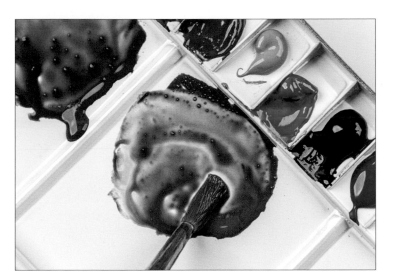

Applying the sepia mix of raw umber and ultramarine blue.

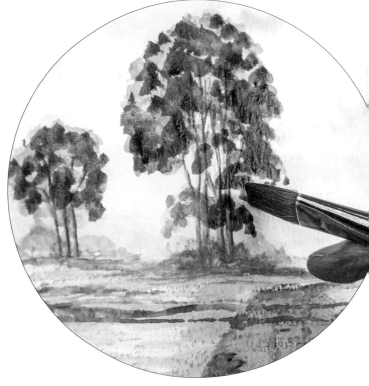

My light areas don't look natural when painted in white

People make the assumption that light is white, and so they use white paint for areas of light, but white is a fairly chalky paint that always looks unnatural, as shown in the two images directly below.

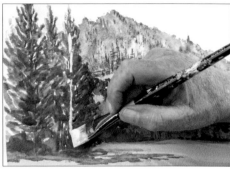

Reinstate a natural-looking light with a light colour instead. Below, I'm using dilute yellow ochre for the grass...

...and for the light in the tree.

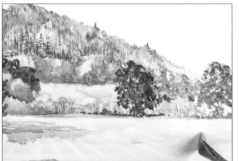

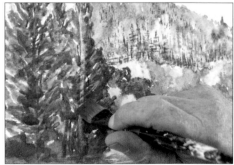

A lot of starter paint sets include white and black. I think this is a mistake. For black you could mix your own black as shown on page 57.

As for white, there is no finer or more effective white than the pure white of your paper. Either paint around the area of light you want to preserve, or protect it with masking fluid.

In an absolute emergency you could use white gouache or Chinese white to depict light using paint, but I wouldn't recommend this.

Depicting light with water

Always remember that white does not equal light. To achieve a lighter shade, you can also mix your colour with water.

Alizarin crimson with water gradually added to lighten.

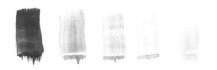

Yellow ochre with water gradually added to lighten.

Cobalt blue with water gradually added to lighten.

Depicting light with sand

Alternatively, you can use a pale shade such as sand to lighten your colours naturally.

Charles Evans sand on its own.

Alizarin crimson on its own, and with sand added.

Yellow ochre on its own, and with sand added.

Cobalt blue on its own, and with sand added – two different strengths.

ACHIEVING REALISM
IN NATURE

I n this chapter, we look at how to rescue and recover natural subjects such as landscapes and the life within those landscapes – trees, grasses, hedgerows, and even people.

For example, a common mistake people make when painting trees is to try to paint thousands of tiny leaves. In fact, I won't be painting leaves on any of the trees in this section. Instead, I'll simply be giving the impression of leaves.

This section is full of tips like this, which may seem counterintuitive at first, but which will actually make your paintings more realistic.

Some of the mistakes in the following chapter have been made by Gail, who has made every mistake possible in her painting career!

 Using her experience, she has tried to replicate – in exaggerated examples – many of the common mistakes I see being made frequently. The painting above is a composite of mistakes; the painting opposite is my corrected version of the same scene.

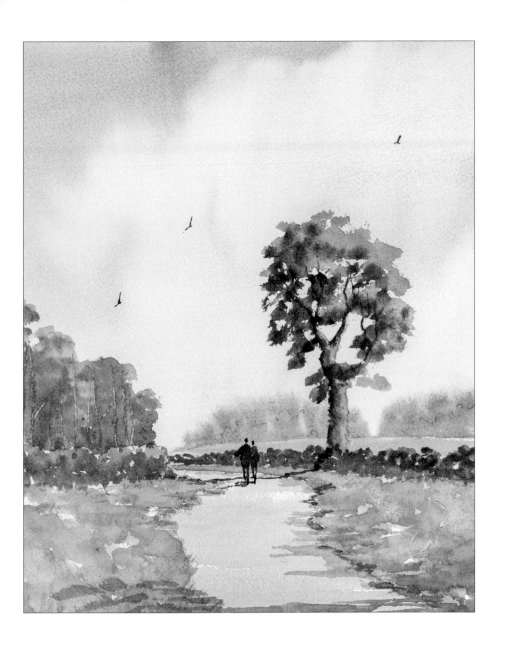

My trees look like lollipops

Sometimes people are so busy painting the foliage on trees that they forget to leave spaces for the light to come through, hence the phrase 'lollipop trees'. When you are painting a tree, you need to leave gaps in the foliage to suggest the sky.

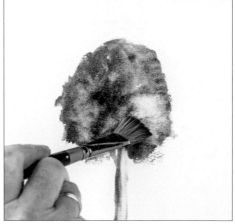

1. First, lift out some of the light from the foliage itself using a clean, damp brush.

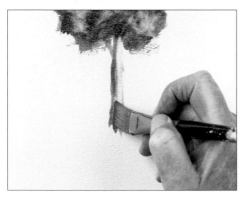

2. Lift some light out of one side of the trunk to round it and make it look less like a lollipop stick.

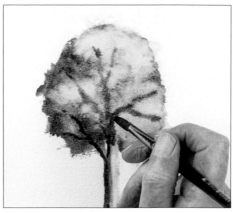

3. It might also help to paint a few boughs on top of the already painted foliage, just to break up that mass of green.

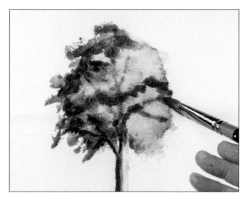

4. Finally, reinstate some of the green lifted out, but leave some boughs showing to break up the profile of the tree.

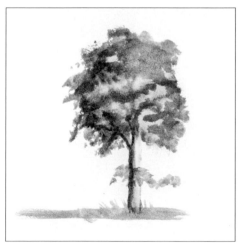

Your rescued tree.

Take time to really look at trees. They are not a regular shape and they are not all sharp-edged. You don't need a degree in arboriculture for this, you just need to look at the tree shape.

When painting in the sky wash, paint through the tree, not around; otherwise you will end up with white gaps in the foliage and between the branches.

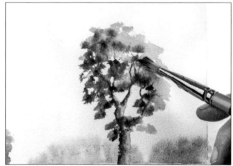

Touch in the foliage a little at a time: it's far easier to add greenery than to take it away!

37. My colours don't look harmonious

The blues look wrong...

In the painting on the right, cobalt blue has been used in the sky and ultramarine blue in the water. The resulting picture lacks cohesion – it just doesn't look right.

If, for example, you have used the wrong blue for your sky, simply wash it out with plenty of water. You won't go all the way back to white paper but you will have faded it out enough to put the right blue on top.

Or, indeed, stick with the wrong blue but make sure it's the same blue you use for the rest of the picture. After all, who's to say it's the wrong blue anyway? It's *your* picture.

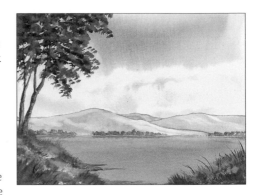

How do I avoid it?

To reiterate, the blue that is in your sky should be the same blue that goes into your trees, your grasses, your water, and so on. This will keep your painting harmonious. The only exception to this would be if you wanted to use black somewhere in the landscape, in which case I would use a mix of ultramarine blue and burnt sienna no matter what blue I had used elsewhere.

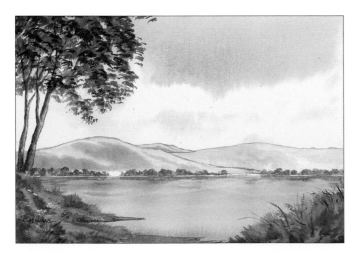

The greens and blues look unnatural...

Quite often, if you are mixing your own greens from blue and yellow, you will change your blues to make different greens. Immediately your colours are not going to be in harmony.

In the example below, different greens and blues have been used within the forest area, and between the sky and water respectively – cobalt has been used in the sky, and ultramarine in the water.

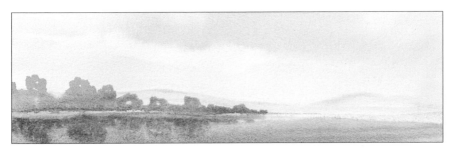

It's much better to stick with one green – Hooker's green – and mix everything else into it, one at a time. This will give you a range of greens, all based on the same colour.

It's difficult to rectify as some green mixes can be very staining and difficult to wash out. By dabbing on with a wet brush, and then taking out with a damp brush, you will take enough out to be able to change the green and put other colours on top.

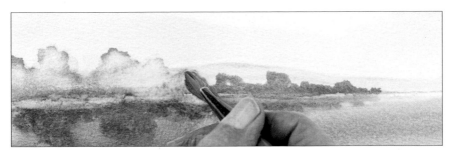

The unnatural, disharmonious greens have been lifted out.

The lifted-out greens can now be painted over, first with yellow ochre...

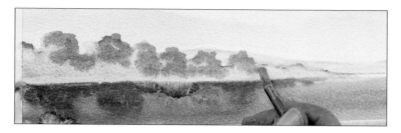

...then a Hooker's green–burnt sienna mix...

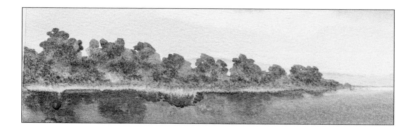

...as well as the blue you've used in the sky – here, cobalt blue.

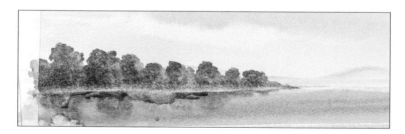

To balance the greens, you can also rebalance the blue of the water, if needed. First wash out the existing blue if it is too harsh or disharmonious.

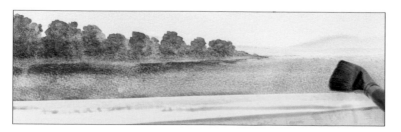

While the paper is still wet, add the blue of the sky back into the water area.

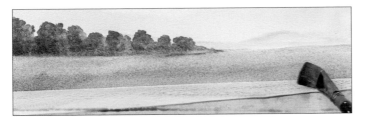

Don't forget to add in reflections in the colours you've used for the corrected greens.

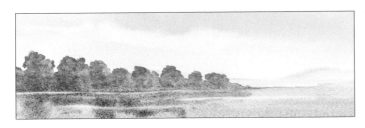

The corrected greens and blues. Notice that I've lifted out some highlights on the water (see page 38) to add more life to the scene.

How do I avoid it?

Some artists paint forest scenes using a huge range of different greens, but, when viewed close-up, this approach results in patches of unrelated colours, all somehow contradicting each other. Thus, the painting is not in harmony.

To avoid this, I mix all of my greens based on only Hooker's green – see page 14. With a little of another colour or colours mixed into it, I can achieve harmonious, yet varied, greens for a landscape painting.

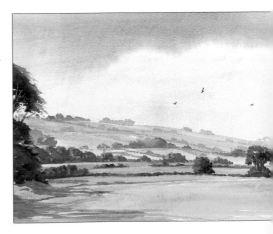

I have trouble painting from a photograph

When painting from a photograph, many artists try to include every single detail of the photograph in the drawing – they may as well just have the photograph.

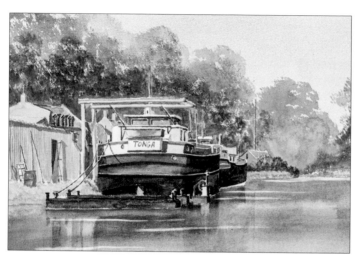

An overly fussy painting...

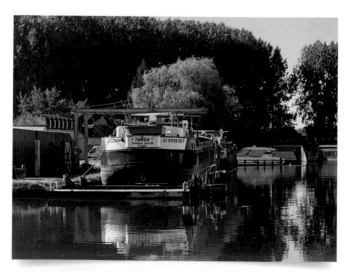

...and the source photograph.

How do I avoid it?

Stick to the main, important details of the photograph that give a true sense of the subject: there will be many bits and pieces you really don't need.

The way to correct this kind of mistake is easy because, as previously mentioned, you will first be making a drawing from the photograph. Take a good, long look at your drawing before you start to paint and, at that stage, consider whether there is too much clutter and detail. If there is, rub it out before you apply any paint.

Use the photograph as guidance for the outline drawing only, and don't slavishly reproduce the source image.

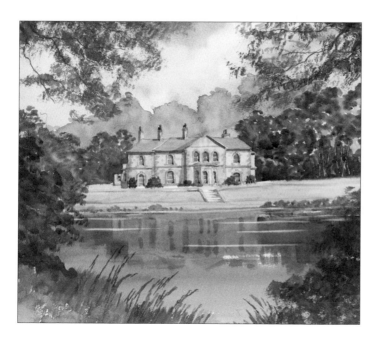

The painting above was based upon the photograph on the right. You'll notice that liberties have been taken with the finer details of the house and grounds depicted in the photograph, in order to create an appealing, balanced composition in watercolour.

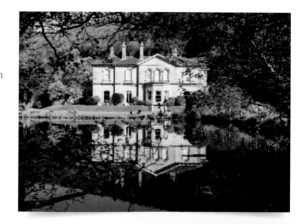

39. My landscapes seem lifeless

Adding a few figures, however small, can add life to a landscape. Adding life does not have to be complicated. It could just be a suggestion that something or someone is there, which can be as simple as adding a few 'ticks' in the sky to suggest birds. Smoke coming from a chimney will also intimate life.

The scene below, left, is fairly static, with minimal suggestion of movement in the waves. But what if I add some people... some seabirds... even a dog? Immediately there is life in the landscape! (See below, right.)

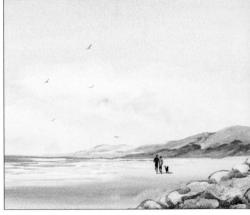

How do I avoid it?

The most important thing with indications of life is that they shouldn't be right in the middle of your landscape or sky. These details are to add life, not take centre stage. Always make these hints of life smaller than you think you need them – use your smallest brush. Don't have too much water in the mix so it won't spread. Also, don't press too hard with your brush.

Another factor that makes some paintings seem lifeless is too many straight lines (some people even use rulers and protractors!). There are very few straight lines in nature, so keep your lines loose and natural.

When I try to add a bird it looks too big and blobby, and ruins the picture

When you come to add birds in the sky to give life to your landscape, you don't need to paint the details. Just a small mark in the sky will tell you it's a bird. I always say, 'a tick with a stick'.

The birds in Gail's example on the right are too detailed for objects in the distance, and are disproportionate to the size of the tree.

If your bird is too large, wash it out, let the area dry and paint it in again, as shown below. If in doing so you lose some sky, either take out a little bit more paint to link in with a cloud, or pop in a little bit more sky blue to replace what you have washed out.

How do I avoid it?

Don't make your birds too big or too detailed – this is not an ornithological study. Also consider featuring an odd number of birds rather than an even number – this makes for a more pleasing composition.

I can't convey drama in my skies

Most of the time, a sky is flat because you haven't got enough movement in it – such as clouds – or you've just used one colour throughout the whole sky with no variation in tone.

 The solution is simple, though: get more colours into your sky – it isn't always pure blue! See below...

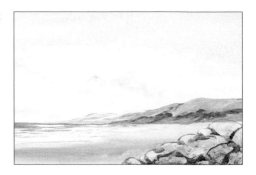

Quite often I will put yellow ochre and burnt sienna into the sky as well as blue, for variation in colour. To give more impact to your clouds, too, place a stronger colour behind where the clouds are going to go. This way, once you suck the paint out to create the clouds, this results in more contrast and more impact. You could consider making the blue of your sky very dark for extra drama. Remember, the paint will dry about 30% lighter, so be bold and adventurous!

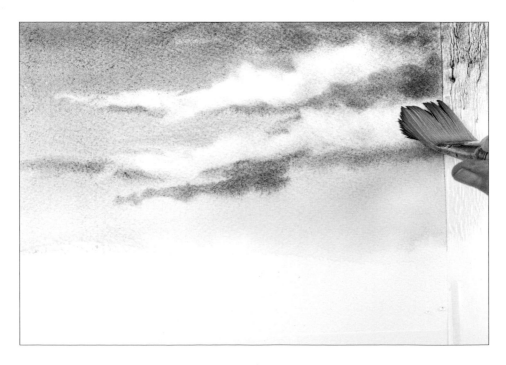

It is very hard to paint a sun or a moon freehand. This is one of the few times you need a mechanical aid because, however you try, you will never get a perfect circle without lumpy bits on the edges. The sun and moon, being so far away, are perfectly round as far as we can see.

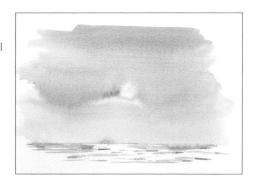

How do I avoid it?

Use a coin (or other, similar round object) wrapped in a sheet of kitchen paper to stamp a perfect, circular sun or moon out of damp paint.

Importantly, make sure the object is wrapped in uncrinkled kitchen paper: if it is wrinkled, you won't get a clear orb. Make sure you hold the object against the paper for a few seconds so that the paper soaks up the excess water – avoid twisting it, or you will ruin the shape (see above, right).

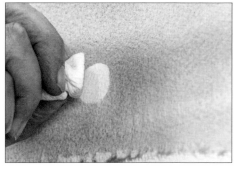

To cover any imperfections, you can paint cloud over the top of the sun, not behind it, in the colour of the sky itself: here, cobalt blue and light red (see below, right).

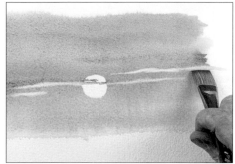

43. I can't paint a realistic sunset sky

The best advice I can give you for painting sunsets is to use the range of colours you see in nature, but remember that they may look unnatural if they are too vivid. Have a variety of colours blending into each other but keep them subtle. You want to avoid a striped sky, as shown on the left.

To correct a sunset that seems to jar, wet the entire area again and then either drop more colour in or take some colour out. Note you can only do this a couple of times before you end up with a mess on the paper.

Then stamp out your setting sun using a coin or similar, as described on the previous page.

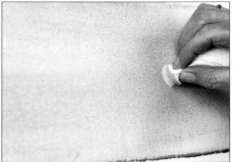

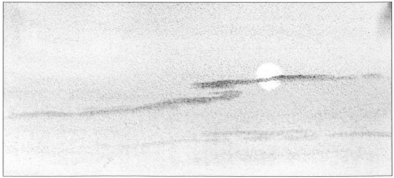

The rescued sunset sky.

Including silhouetted trees or buildings in your sunset scene sums up the time of day and contrasts really well with a beautifully lit sky. Let your sky dry before applying the silhouettes as they need to be kept quite sharp.

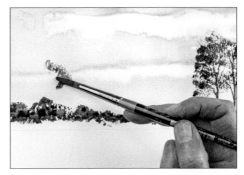

How do I avoid it?

How often have you heard people say, 'look at that sky! If I painted it like that, it wouldn't look real'? Well, no, it wouldn't. So, don't.

For a more realistic sky, tone those colours down, and let them run and merge before using a softer red – such as alizarin crimson – over a more vibrant red such as light red, so it is not too bright.

Remember that, in a sunset, the sun has already gone down, so the light in the clouds will come from underneath.

A successful sunset sky with silhouettes.

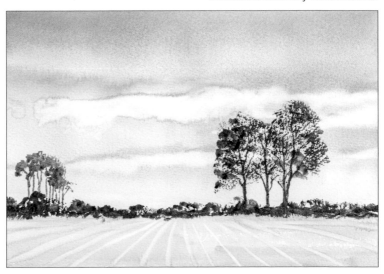

44. My distant trees don't look distant

In Gail's example, right, the trees and foliage in the distance are as dense and bold as those in the foreground, so you cannot get a sense of distance, or aerial perspective.

A simple way to show aerial perspective (which indicates far-off objects) is to paint your distant objects as hazier, less detailed, weaker and blue-tinged.

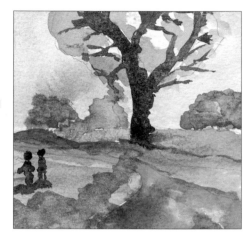

How do I avoid it?

If you want to push an object back into your picture, wash out some of the colour and add a blue tinge. Don't forget, your blue will be the same as in your sky. As you can see in the example below, I have painted the trees softening into the sky, and the colours are weak and tinged with blue.

Don't make distant trees as strong in colour as foreground trees: try to achieve tonal differences, as this will help convey recession as well.

Aerial perspective

This is the effect that light and the atmosphere have on our perception of distance: an object far away from us will be obscured by light and by detritus in the air, so its colour will appear hazier and less defined than that of objects near to us.

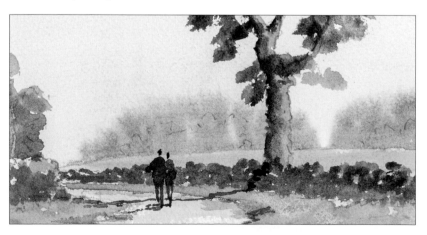

I can't seem to get my shadows in the right place

In Gail's example on the right, the shadows are at odds with the direction of the sun, and are unevenly dappled so it's impossible to determine the surface of the path.

You can always wash out incorrectly placed shadows as long as you haven't made them too dark in the first place.

How do I avoid it?

By the time you get to painting the shadows, you should know which side the light is coming from. Always paint the shadow on the opposite side of the object to the sun as the object is, in essence, blocking out the sun, causing the shadow.

When you're depicting shadows cast by trees or people, touch the bases of those details with the shadow mix and drag the shadow away. Don't leave a gap between the object and the shadow.

Don't forget that the shadow, wherever it's cast, will follow the contours of the land. In addition, always suggest something out of shot in the painting, casting another shadow: this adds more realism.

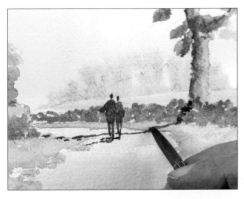
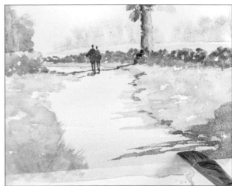

I can't seem to mix a good colour for shadows

In this example, by Gail, the shadows look to be the wrong colour because they are not harmonious with other colours in the scene. Often, the assumption is that a shadow is simply a shade of grey, but any shadow that you paint needs to include hints of the colours you've already used, such as the blue of your sky.

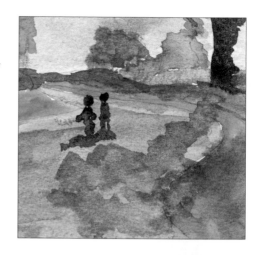

How do I avoid it?

When making up a shadow mix, you're looking for a dark aubergine colour that includes the blue that you have used for your sky wash: in this case it's ultramarine blue, mixed with alizarin crimson and burnt sienna.

Continually adjust the proportions of each colour to ensure that you achieve a natural, well-balanced mix.

I recommend having a spare piece of paper to test your colour mix on before actually committing it to the painting (see right): this is an important, and rather staining, colour mix.

My figures don't look right

The main problem always seems to be that people make the heads too big for the bodies; so make the head smaller than you think is correct. This is not portrait painting, this is just adding life to your landscape painting.

How do I avoid it?

Keep the figures smaller in the middle distance, and don't put in too many details of heads, bodies and clothing. Remember you are adding life, not creating a life drawing.

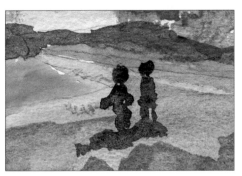

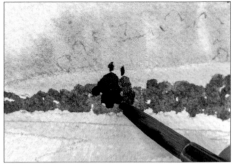

To correct, simply wash out the figure with your 19mm (¾in) flat (this brush is nice and sturdy for washing out). Let all this washing out dry thoroughly before replacing the area of landscape that you will have also removed. Again, let this dry and then replace the figures.

Always consider the size of your figure in relation to their placement in the landscape.

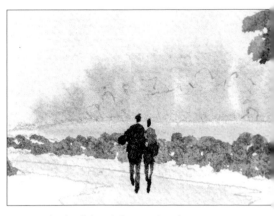

A good rule of thumb for gauging the proportion of a figure is that the head of an adult is roughly one-eighth of the body height, so from dotting in the head, you can work out fairly accurate proportions for the rest of the body and avoid making the head too bulbous.

48. I can't paint realistic skin tones

People can often get very confused with skin tones because there can be many different tones under the umbrella of 'flesh tone'.

If you need a paler skin tone, you can mix a pale shade such as Charles Evans sand or yellow ochre with a touch of light red and an even tinier touch of ultramarine blue (see below, left).

For a darker skin tone, add a tiny amount of ultramarine blue to darken the tone. Remember, I'm not talking about portrait painting in this instance, rather depicting a few distant figures in a landscape painting.

For people in the distance, you can paint in the faces as simple blobs.

I can't paint a crowd of people

Lots of painters are scared of painting a whole crowd of people because they think that they need to go into detail on every single figure. But you are only *suggesting* a lot of people.

The crowd shown on the right is unsuccessful as there is too much of the same colour prevalent in their clothing, and no recession – all five people are on the same plane, so they appear as an indistinct clump.

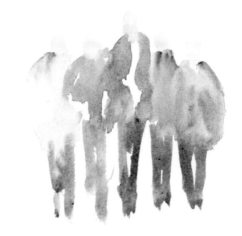

How do I avoid it?

If painting people from a distance, you can choose colours for the figures' clothes that will really stand out: for example, alizarin crimson, cobalt blue, and light red and yellow ochre mixed together for a pleasing orange-yellow. Leave one individual's clothing white with just a little bit of ultramarine blue for shadow. Finally, paint one person's clothes in Hooker's green, which works perfectly for an unnatural object in a scene!

The crowd scene below works more effectively as the people further back in the crowd are recessed so there is a clearer impression of distance and depth to the group.

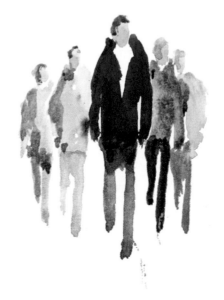

My tree trunks look flat and shapeless

Normally this is because you have one colour throughout the tree trunk. You should always be thinking that the light is going to hit the tree trunk somewhere, and some parts of it are going to be in shadow.

This is easy enough to rectify, however – with a clean, damp brush, gently lift out the light on the side of the trunk that the sunlight is hitting. This will immediately lend more shape and roundness to your trunk. Enhance this by putting in a black, or shadow, mix on the other side of the trunk for contrast.

How do I avoid it?

I always use three colours when I am painting closer-up tree trunks: a light tone, a mid-tone and a dark. I use yellow ochre for the light side, raw umber for the mid-tone and a black mix for the dark side – the black mix being ultramarine blue and burnt sienna.

Always make sure that all three colours go on while the first colour is still wet so the colours run and merge into each other. This will give a rounded look to your tree trunk.

If necessary, change to a smaller brush for the finer elements of the tree.

Also, don't have twigs and boughs the same width and thickness. Remember, they get thinner as they come further up the tree.

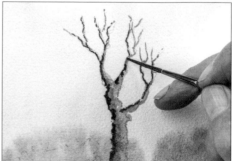

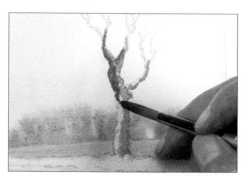

It takes me too long to paint foliage – all those leaves!

People often think you need detail in foliage, and to depict every single leaf. However, you just need to *indicate* a mass of foliage and your brain will fill in the rest. Remember if you put lots of details in every tree you paint, the whole painting will look flat because all the detail is the same.

However, this is an easy one to rescue – first paint some of the leaf detail as shown, then you can fill in the gaps. Simply change your brush, and method, to give the impression of dense foliage rather than describing every leaf, twig and bough.

Split your brush in the palette and fill in the gaps to give the impression of fullness, as shown below, using a stippling motion.

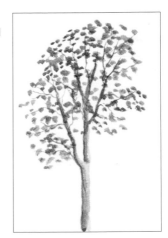

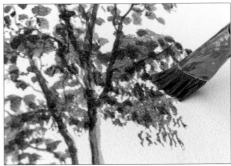

How do I avoid it?

Make sure that you leave gaps in the foliage that reveal the sky wash – you don't want trees that look like lollipops (see page 66).

Use the side of a fairly big brush, such as a 19mm (¾in) flat brush, with yellow ochre to represent light, and three harmonious tones of green, rather than one flat green. Don't fill in too much colour. Remember also that you want the boughs and twigs to show from within the foliage (i.e. not concealed or painted over the top) so obscure them with the foliage.

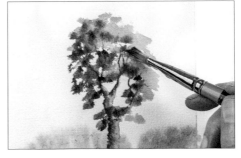

Finally use a touch of the blue you've used in the sky – here, ultramarine blue – for the very dark details.

52. I've tried to scratch out branches and my trees look wrong

You may not have waited long enough for the paint to start drying. If you are scratching out details from your painting, the paint must not be too wet, as you risk the paint flooding back in as you scratch out. All you will have done is make a mark on the paper rather than taking out the paint.

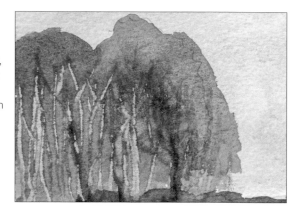

How do I avoid it?

To achieve a bit of detail, rather than painting in to the trees, take out: scratch subtly with a fingernail, with a single stroke into the trunks when the paint is damp, rather than wet.

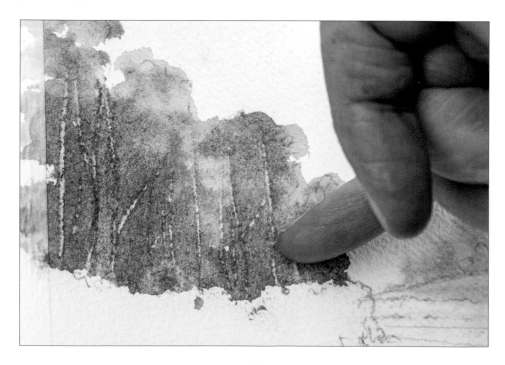

My hedges look wrong

You don't want your hedge to be too flat with too sharp an edge on the top; you need to break it up and make it a bit bumpy along the top. Remember, this is a hedge, not a green wall. Similarly, in contrast to Gail's example below, your hedges need to be given some texture, otherwise they will look flat and will merge – unnaturally – with your other areas of green.

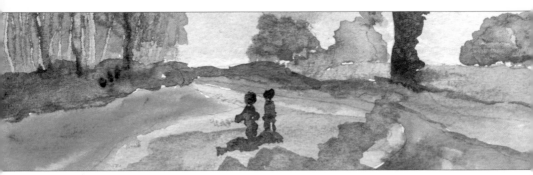

How do I avoid it?

Either use a round brush and stipple on the paint so that you don't end up with solid clumps (which may result in hard edges) or use a 19mm (¾in) brush. Split the brush in the palette, and stipple onto your paper (see page 87) to give broken patches of greenery and browns. This is much more effective and doesn't give you solid and unbroken areas.

In the image below, you will notice that the hedge on the left is lighter than the hedge on the right, because the light is coming from the right in this painting; to achieve this lighter area, I have used Hooker's green and yellow ochre.

Throughout a painting, always bear in mind where the light is coming from. If you can't remember, and a lot of people have trouble remembering (sometimes I can't remember my own name), draw a little arrow on the masking tape as an *aide-memoire*.

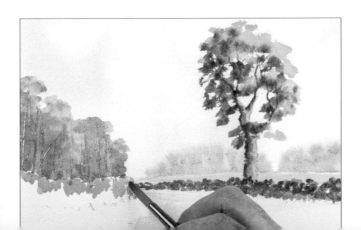

When I paint lots of trees, the greens all merge into one

One reason could be that the trees are all too wet when you put them in, so they are merging and bleeding. Another reason could be, even if they are not merging into one another, you are not varying your mixes enough (at different strengths). Remember, the trees in the distance are not all on the same plane. Even if they are within the same woodland, some trees are nearer the viewer, and some are further away.

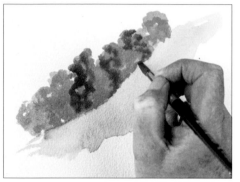

1. To fix the merging greens, you'll need to add some more light and dark areas to distinguish the greens from one another. Begin by going in with yellow ochre, then a mix of Hooker's green and burnt sienna (heavier on the burnt sienna), then ultramarine blue – essentially, the components of the greens you've already placed.

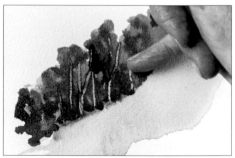

2. Then reintroduce more light by scratching out trunk details with a fingernail.

How do I avoid it?

To prevent bleeding in, let one colour dry before you introduce another.

Always make sure you are changing your colours sufficiently; vary the colours you put into your initial Hooker's green mix to keep the colours fresh.

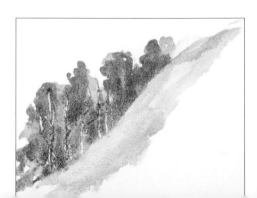

55. My grassy areas look flat and unnatural

Most of the time, this is because you have painted your grass in one solid colour with no variation or contrast.

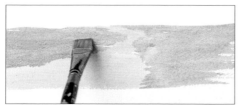

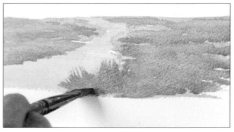

1. Invariably, you need your grasses to be a lighter shade of green than the foliage on your trees.

Start off with a little bit of yellow ochre, fairly haphazardly slapped on within the grass area, and then go over the top of this with yellow ochre and Hooker's green, mixed, while it is still wet. Leave some yellow ochre showing through here and there. This should offer sufficient variation. You can even add a little burnt sienna if you wish.

2. Add some grasses for texture and movement by flicking upwards from the paper surface with the bristles of your flat brush.

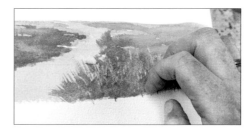

3. As on the previous page, you can also scratch out some grasses to introduce areas of highlight.

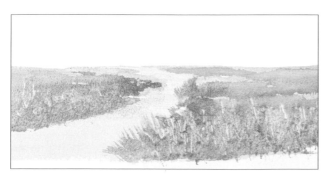

The rescued grassy area.

My fields look undefined

Quite often, the flatness will come from just using one colour and without showing enough recession (wherein the colours get weaker further away) within that colour.

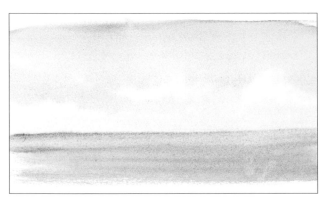

Always vary the colour and never use an unnatural green such as Hooker's green by itself.

How do I avoid it?

Make sure you have a mixture of colours for the field, dropping in various shades of your main colour while it is still wet.

Then anything within the field – hedges, trees and bushes – will need a shadow leading away from them into the field. Again, this breaks up the field and adds more realism. If you are using a lifting-out technique for details such as plough lines, make sure that the gap between the lines get narrower as they go further away. This, again, adds recession to the field.

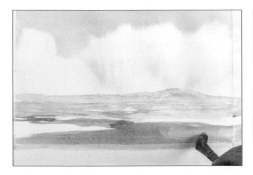
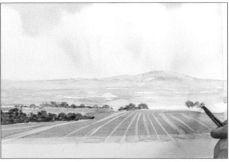

In nature, very little has straight lines and sharp edges, yet so many people want to tidy up their paths when they are painting them. But remember, this is a track, not a motorway.

In the example on the right, there are harsh lines where the grass ends and the path begins – ideally the two should merge so the path doesn't look man-made.

To rectify this, you could try flicking up a few strokes of grass on either side, to break up the edges of the path.

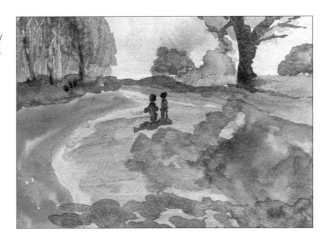

How do I avoid it?

Always paint the path in first so that you can overlay the edges with vegetation, as in nature. Break up the edges of the path where it meets the grass by adding a few flicks of grass onto the path, using the same colour that you've painted the grass with. Make sure that your edges are not straight but irregular.

Use big, broad strokes that overlap the grassy verges; ensure that the path gets weaker in tone as it gets further away.

To create soft edges on the banks of grass on both sides of the path, you can follow the instructions on page 91 for giving dimension and texture to your grassy areas.

58. I want to show ripples and waves on water but they don't look right

The most common thing people do incorrectly when painting ripples is to make them all perfectly straight, horizontal marks and all the same size. Also, there are usually too many of them.

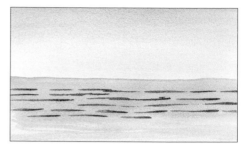

To correct, wash over the entire area to soften it and then reinstate the ripples. Remember, less is more.

Make the ripples more undulating and realistic, and fade the colour for the more distant ripples, by adding water to your brush. Make the ripples different lengths and widths.

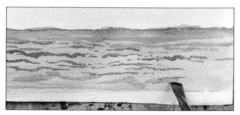

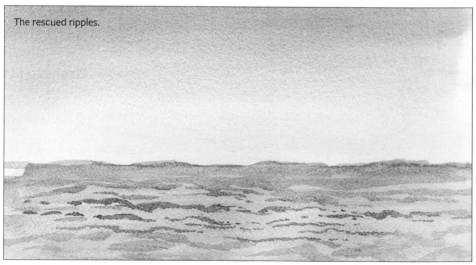

The rescued ripples.

How do I avoid it?

You don't need to cover the entire area of water with ripples. Paint a few in the foreground, fading off to nothing as you move further away.

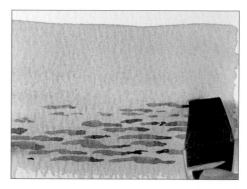

Begin with a flat wash of light blue (here I have used cobalt blue) and allow it to dry. Then, with the tip of a 19mm (¾in) flat brush, put in small, horizontal brushstrokes using the same colour mixed with a touch of burnt sienna.

As these very simple strokes recede into the distance, make them shorter, and use a slightly weaker mix by adding more water.

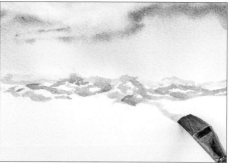

You will end up with a flat, lifeless sea if you don't have any change in the colour as it goes further away and if you paint it in straight lines. This will automatically flatten the sea, so make sure that the colour becomes gradually darker towards the foreground, but leave strategically placed areas of the white paper showing through – this is critical.

To paint a choppy sea, don't paint in straight lines. Move the brush up and down as well as from side to side, to create movement. Make sure that the shadows underneath the waves are stronger in the foreground, getting weaker as they recede. These strong, dark shadows underneath the white areas that are left will add real impact and movement to the sea.

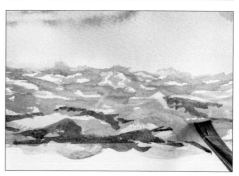

Underneath some of the white areas, place a few darker details – introduce a touch of burnt sienna into a blue-green mix and place a hint of shadow under the waves.

Avoid placing these shadows too far back: reserve them for the foreground. The last thing you want in a rough, dynamic sea is a flat swathe of blue.

My sun sparkles on water never seem to look right

To achieve sparkles on water, you need to be using a Rough textured paper. Smooth or hot-pressed paper will not give the right effect.

In the scene on the right, the sparkles are very muted, so the water looks flat and lacking in light.

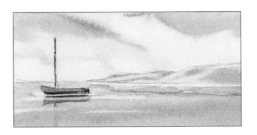

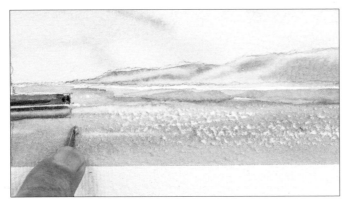

If the whole area is filled in, wait until the paint is totally and completely dry, get a scalpel and very lightly scrape the surface. This will take off the top layer of paint to reveal the paper underneath. This technique should be used sparingly and you will only have one go at it.

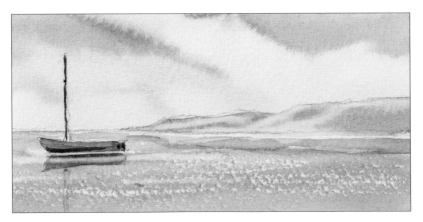

The scene, rescued by sun sparkles.

How do I avoid it?

Mix cobalt blue, Hooker's green and burnt sienna, and load your brush with the bristles flattened into the palette.

Apply the sharp edge of the brush to the paper, and use a dry-brush stroke to catch the surface of the paper. (A dry-brush stroke is made by a dry brush dipped into the pre-mixed paint, with no excess water added.) Leave a few tiny touches of the paper showing through. More sparkle is required, the further you come into the foreground.

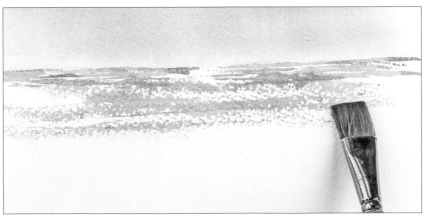

60. I can't get movement into my waterfalls

This is most likely because the water has been painted as a solid clump. You need to have plenty of white showing in this body of water to give the required movement.

You can lift out the light to rectify the problem, but it may be easier to start again, following the instructions below.

Remake your water mix but make it stronger, with less water. Now, with a 19mm (¾in) brush, well and truly split, lightly and gently stroke in the direction of the flow so that you are leaving areas of the white paper showing through (see right). To show the waterfall pouring downwards, be really hard with the brush in the palette in order to split it but gentle when you are applying this to the paper. A light stroke across the paper will leave the brush split, whereas pressing down too much will close up the brush hairs and will not give the desired effect.

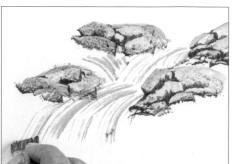

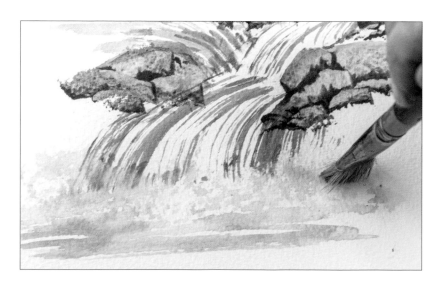

I can't paint realistic rocks

If the rocks are looking a little bit mushy, the most common problem is that you haven't gone on strong enough with the colour or you have too much water in the mixes.

The solution to this is to quickly reapply paint with the same colours, making sure that the paint is good and thick.

Go back in with your credit card. You must be fairly hard with the card and scrape into the paper. Also, the paint for the rocks must be good and strong. You are aiming to describe the areas of dark shadow and contrasting sunlight, on and between the rocks.

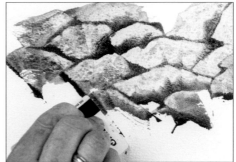

How do I avoid it?

When you are scraping out the rocks with the card, be sure to leave a gap between each scrape, which is where the wet paint will gather and give you the shadows between the rocks. For this reason, it is better to start at the tops of the rocks so that the paint can run down.

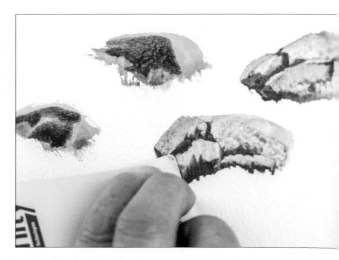

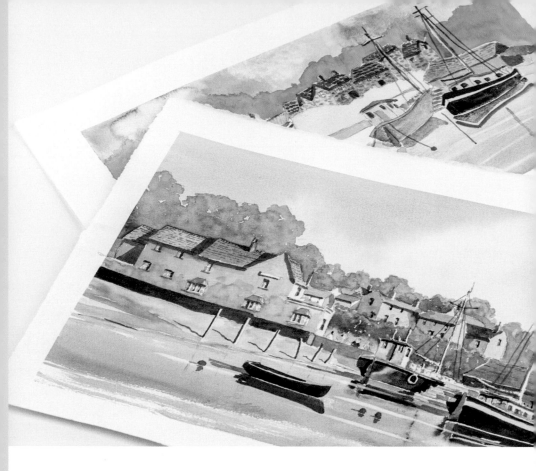

ACHIEVING REALISM
IN BUILDINGS AND
STRUCTURES

Painting buildings and man-made structures can be daunting. Start by practising with something easy such as a little cottage and then work up to something more complex.

Remember to observe your subject carefully. Look at the lines with which it is constructed, and the angles they make with each other. Is the structure on your eyeline or are you above or below it? One of the most important lines of a building is the roof line. This will determine the direction in which the building is facing.

When it comes to putting on the paint, there will always be a light side and a dark side to your structure. This will give your painting depth.

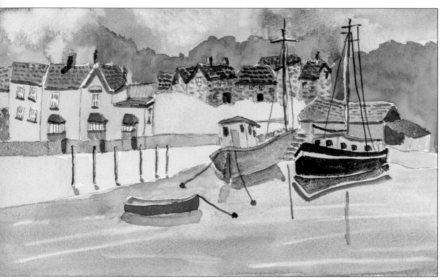

This painting of Gail's (or as I like to call it, one of 'Gail's Fails') shows common mistakes that I frequently see in my classes. I will be pointing out her mistakes and rectifying them so that the painting will be technically 'correct'. (Gail maintains she made all those mistakes deliberately for the purposes of the book.)

On the opposite page is my 'rescued' interpretation of the same scene. See if you can spot all the differences!

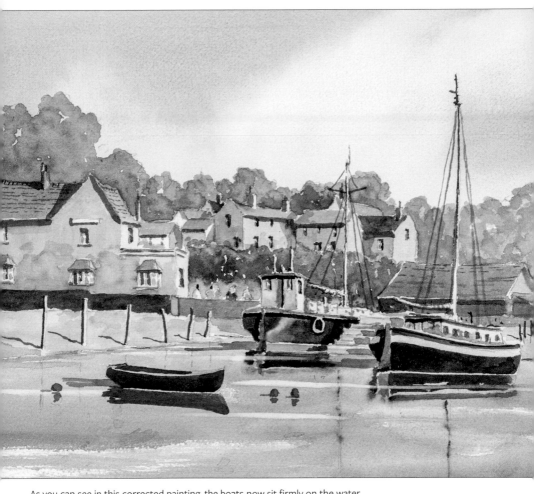

As you can see in this corrected painting, the boats now sit firmly on the water with clear reflections and look more seaworthy than the originals. The roof lines are running the way they should, with corrected shadows and windows, all backed by nicely distant woodland.

62. My buildings look flat and lifeless

Very often, buildings look flat because little attention has been paid to correct scale and perspective. Roofs, door frames and window frames slope or recess away from us as we view them in real life – and our depictions of buildings should do the same.

Likewise, older buildings have uneven details and quirks, all of which give them charm and character.

Don't use perfectly straight lines to draw your buildings; this is not an architect's drawing. Add a little more character and charm to the building with a few wobbly bits.

How do I avoid it?

If everything is looking stiff and lifeless even at pencil stage, before you start to paint, erase a few choice areas.

Speaking of erasers, I never use putty erasers because I find that they fall apart and get really mucky and messy. I use a good, old-fashioned school eraser. If you find pencil lines you don't want once the painting is done, a hard eraser will take these out whereas a putty eraser will struggle.

You could add a little bowing to the roof. It's also good to feature lots of vertical lines when you are painting a lot of buildings, so add a few more chimneys.

This very simple format can be useful for creating all manner of buildings, from little cottages to terraces; just make the basic structure smaller, or taller, add more or fewer chimneys and windows, and you'll still have a realistic, characterful house.

When you come to paint the building, decide on the direction of light. Make a clear, strong difference between tones to give the building depth and shape.

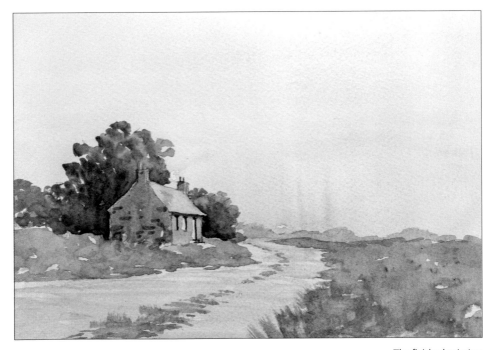

The finished painting.

Sometimes people look at a roof line and literally cannot see which way the roof is sloping. I'm not sure why this is, but it happens. In this example on the left, the roofs of these adjacent terraced houses all slope in different directions!

How do I avoid it?

If you're out on location, look properly at the actual building you're intending to paint.

Hold a pencil horizontally in your outstretched hand while looking at the roof. It will then become clear to you which direction the roof is sloping in. Is it falling away from the pencil or is it going up through the pencil? Once you have the first roof drawn, the others will follow.

Make sure that the tops of the windows run parallel with the roof line – likewise for the top of the door.

My windows look wrong

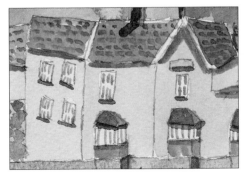

The topmost frames of the windows on the left do not line up with the roof lines, or each other; and the details of each pane of glass look too fussy and untidy.

Unfortunately, at this stage there is not much that can be done to rescue this part of the painting – it's best to start again, following the instructions below.

How do I avoid it?

When you are drawing a window, make sure that the top line is running parallel with the roof line. The sides of the windows are always vertical (that is, at 90 degrees to the bottom of the painting).

Don't start drawing individual window frames, these will be intimated with the paintbrush. All of this should be resolved at the drawing stage so then you are ready just to fill in with paint.

When you're painting distant windows you don't need to put in details such as curtains. You also don't need to start painting individual window frames – simply paint panes. These can be no more than a blob of colour with the white paper left showing in between. To define the panes, simply paint in an upside-down tick. The same applies for doorways and steps.

Put these windows in using a black mix of ultramarine blue and burnt sienna in unequal quantities.

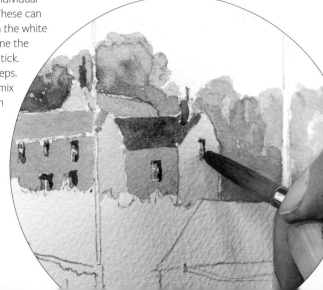

My stonework or brickwork looks unnatural

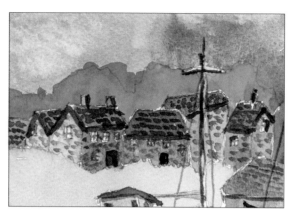

Most of the time, the reason stonework or brickwork doesn't look natural is because it is far too busy. Less is best. If you put less detail in, you allow the viewer's brain to fill in the rest.

Unnatural brickwork can be rectified by lifting out the fussy detail with a clean, damp brush, allowing the painting to dry again, and then going back in following the instructions below, though it's usually best to aim to get it right first time.

Follow the instructions for rescuing roof tiles, opposite, to rework your brickwork if you can.

How do I avoid it?

Working wet-into-wet, put in just a few occasional strokes on a small brush to suggest stonework, rather than painting every stone.

A few strokes, following the roof line or top of the wall or bridge, for example, will intimate detail. You don't want your stonework or brickwork to look like it has measles! Less is best.

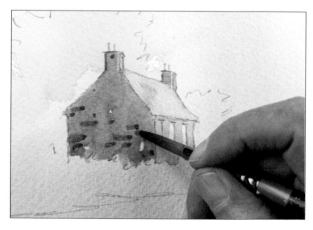

66. I always end up painting individual roof tiles

Just as with the brickwork in a building, people sometimes feel that they need to paint every tile. Again, this looks too busy: simply give the impression of tiles.

However, you can rescue a roof of unnatural or fussy tiles!

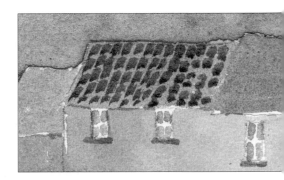

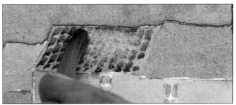

1. Wash the tiles out using a clean, damp brush.

2. Let the roofs dry, then redo the tiles following the instructions below.

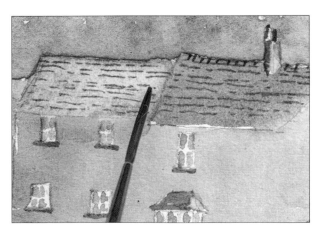

3. As with the brickwork, show a suggestion of tiles in burnt sienna with a touch of ultramarine blue to darken. Apply a few broken, squiggly lines on a rigger. Make sure that these broken lines run parallel with each part of the roof.

For the tiles on the tops of the roofs, put in a few diagonal strokes in the same colour.

When vertical lines appear in a painting, they are usually used to depict something structural and man-made; but even these don't have to be perfect.

However, in the examples on the right, the groynes look like they're buckling and unsteady, they are also of similar sizes so do not look like they're recessing into the distance – a little more accuracy might help them look realistic.

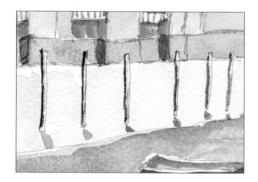

How do I avoid it?

If you have a problem painting short, straight lines with a brush, use a credit card instead.

As shown below, make your paint mix good and dark but with plenty of water in it. Dip the edge of your card into the paint mix, making sure that the whole edge is covered with the paint. Put it on the paper with just the sharp edge that is covered with paint, press it down hard but don't move the card around on the paper. So really, it's a quick, hard dab with the card.

Alternatively, you can paint lines at jaunty angles on purpose – see below right. These poles are old groynes that have been there for centuries. I've painted my version of the groynes in ultramarine blue and raw umber mixed, to make a sepia, and left the right-hand sides the white of the paper.

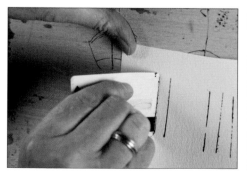

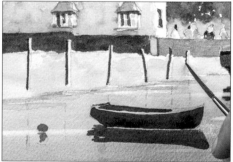

I can't paint realistic-looking boats

People worry about painting boats: I think of them as differently-shaped buildings – that eases the pressure!

In this scene there are two larger boats and one smaller boat. Ask yourself, if you were standing at the harbour, looking at those boats, would you want to get on board, and expect to get out alive? I doubt it! They are uneven and misshapen and don't sit level on the water.

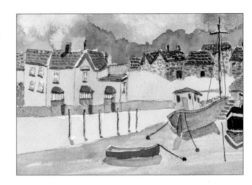

How do I avoid it?

We'll start by reconstructing the large boat in the centre of the scene.

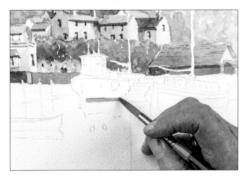

1. The base can simply be a strip of light red.

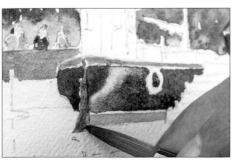

2. Paint the bulk of the hull in a black mix – paint around the rudder and the suggestion of a life belt. Then lift out light to intimate the shape of the hull using a damp, clean brush. Curve the stroke as you take out the colour.

3. Paint the top of the hull in Hooker's green on its own – remember that 'unnatural' items can be painted in this particular shade. The rudder can go in with a stroke of raw umber.

4. When you come to paint the cabin, paint only the shadow side – leave the light side unpainted. In thinking of the boat as a building, the addition of shadow will bring it to life and give it shape.

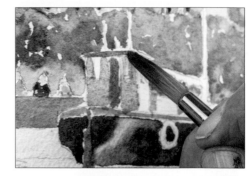

5. Paint down the left-hand side of the mast, and underneath the boom, using a shadow mix of ultramarine blue and burnt sienna on a rigger to give both details shape and dimension.

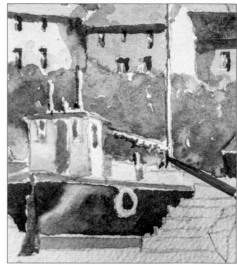

6. For the rigging, apply your black mix. Avoid being too careful and cautious when painting as you are liable to end up with blobs in your rigging. Instead, put your rigger brush onto the paper and pull down the paint in one quick stroke – rigging is, after all, what the rigger brush was made for!

If there are any gaps left in your rigging, the eye will fill those in.

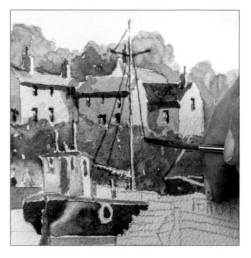

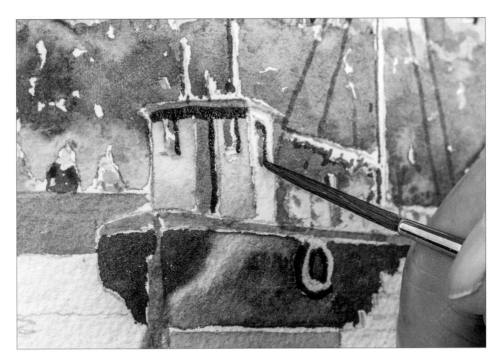

7. Add some clutter on board the boat – remember, this does not need to be accurate; simply put in some blobs, squiggles and vertical lines as suggestions of clutter.

Finally, place shadows under the roof, and inside the doors and windows following the guidance on page 107.

Your larger boat is complete, and looks realistic within the scene. See page 116 on painting the water beneath the boat; and page 115, overleaf, for guidance on painting realistic reflections.

8. Let your water wash dry before painting the smallest boat over the top of it. With a mix of ultramarine blue and burnt sienna (heavier on the blue), block in the small boat using a number 8 round brush and small strokes. Leave a gap of white at the top of the boat, and between the boat and where its reflection will go (see overleaf).

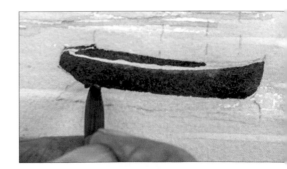

My reflections look like they are stuck on

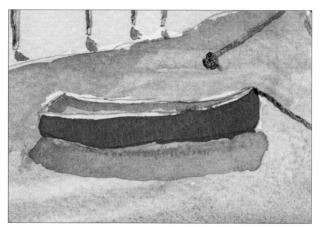

In Gail's painting, the shapes of the reflections don't match the shapes of the objects being reflected, so the eye does not see them as reflections.

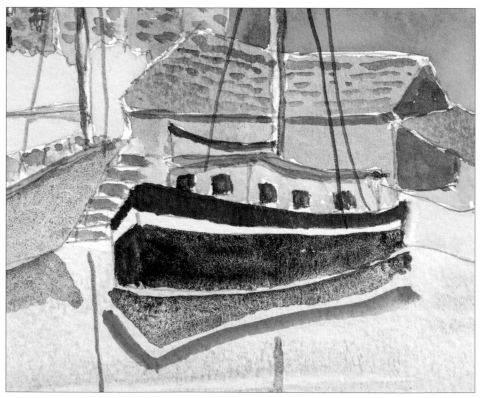

How do I avoid it?

As I've mentioned on page 113, one way to avoid this problem is to leave a strip of light between the object and its reflection, as shown on the right.

Another way is to paint the reflection before you paint the water over the top, as shown below. Simply repeat the colours of the boats themselves in the reflections.

As long as your reflections are dry, you will soften them without moving them. Use a mix of ultramarine blue, Hooker's green and a touch of burnt sienna for the sea, with plenty of water in the mix.

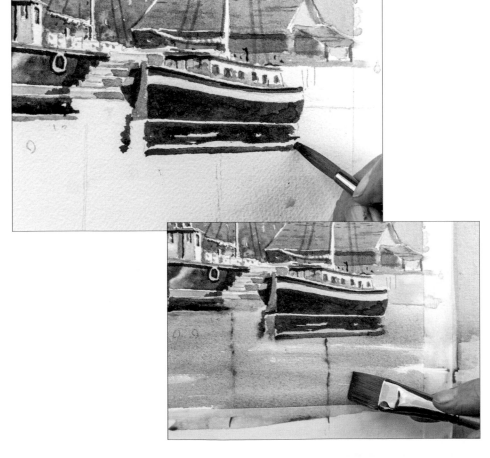

If you want to ensure more natural sparkle on your water (see page 96), work across the paper with a light touch, allowing the white of the paper to shine through.

To introduce more light ripples on the water's surface, wash out your brush, squeeze out any excess moisture, then, with the sharp edge of the brush, suck out a few lines of paint for light.

Remember, as with any other effective technique, less is best! Make sure the shafts of light all run in the same direction.

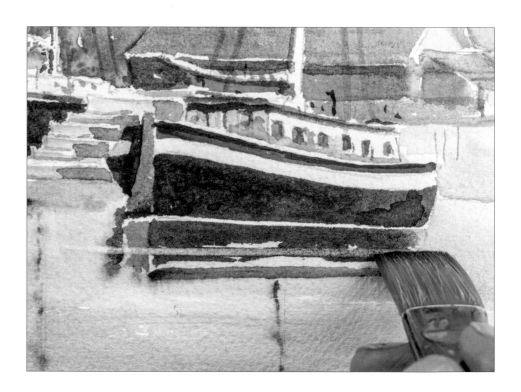

One thing people forget about painting water is that, as well as reflection, there is shadow in shallower water.

The two big boats and one small boat in this scene should all cast shadows – in the same shadow colour – onto water. Buoys will also cast shadows.

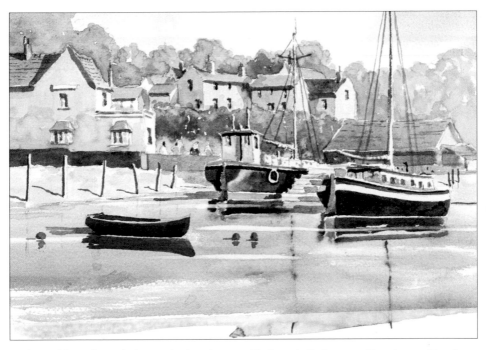

The problem of unrealistic cast shadows is tackled on the next page.

The buoys in the foreground have been put in using an orange mix of yellow ochre and light red. They also have reflections and a hint of shadow to give them shape and settle them on the water.

My cast shadows look unnatural

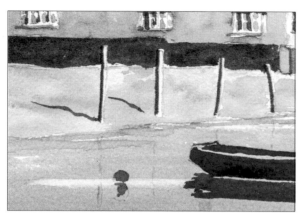

Any static object needs a little bit of shadow to tie it to the ground. In the example of these groynes, look at the far-left groyne compared with the one beside it.

Whatever is casting the shadow should be touched by the shadow.

In addition, the shadows do not echo the forms of the groynes, or follow the contours of the sand.

In this example, it's easy enough to 'rescue' the wrongly-cast shadow – simply join it to the base of the object casting it; you may also be able to give the shadow a little more 'wiggle' to intimate the sand.

Keep in mind the direction of sunlight and also of the surface onto which your shadows will be cast: shadows over grassland or sand need to follow the contours of the ground, so they will not be poker-straight.

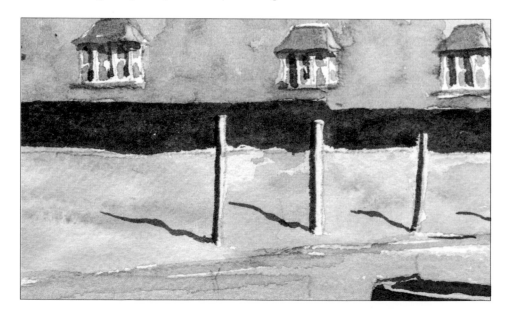

How do I avoid it?

In the examples below, the sunlight is coming from the top right of the scene.

When painting cast shadows in crowded areas, such as over rooftops, think of what will cast shadow, and on what: which building will cast a shadow on its neighbour, and on itself. For example, where a roof meets the fascia of the building, place a nice shadow line straight across beneath the overhang of the roof.

Chimneys, too, will cast shadows on the roofs.

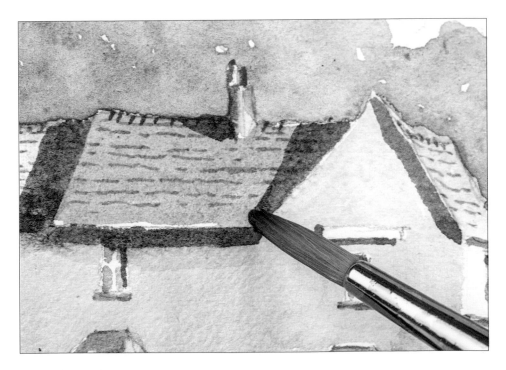

I've missed out a bit of the background!

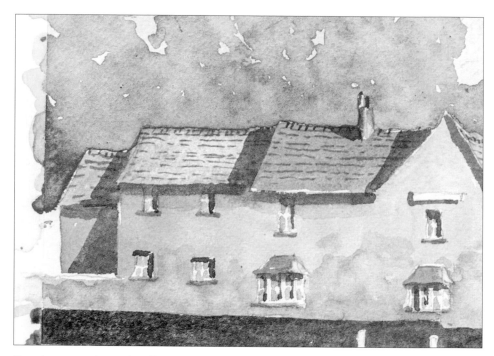

If you have missed out a bit of background, you can always go back in and paint it afterwards. But always remember, when you do this, to fade it back to fit behind whatever is in front of it.

As I always say, paint from the top (the sky) downwards, filling in your pencil marks from your initial drawing as you go. Then this is unlikely to happen again.

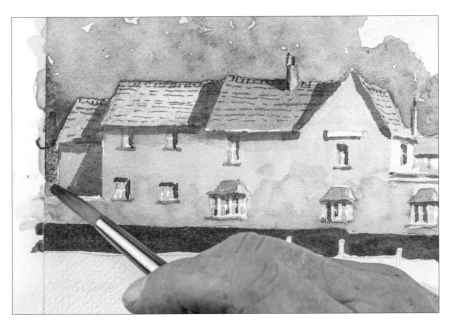

Fill in any gaps with a touch of your sky blue, letting it merge in to the base of any trees.

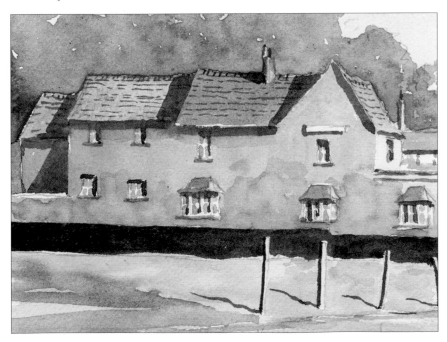

The background now looks seamless!

ENDGAME

So you've done your painting, you can't see where it could be improved upon – what happens then? Well, if you are pleased with it, get it framed and up on your wall or give it as a present.

This section, however, explores a few questions you might have if you aren't entirely pleased with your picture. I have a few suggestions to reassure you that it has all been a worthwhile experience.

72. I don't know how long to keep working on a watercolour painting – days, months, years?

There is no limit to how long you can continue working on your painting, but when you can't think of anything else to do, this indicates that it is finished! Also, bear in mind that you can overwork a picture so that eventually it loses its freshness.

What I would always suggest is that when you think you have done enough in a painting, walk away from it and leave it for a couple of days. Come back and look at it with fresh eyes and you will be amazed at what the painting fairies have done to it while you have been away! But as I always tell my students, if in doubt, leave it out.

I don't like all aspects of my picture but some of it I do like

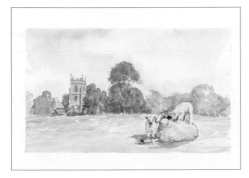

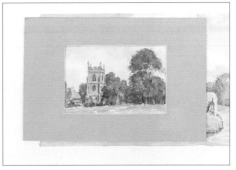

Look at your work when it is finished and spend some time deciding what you particularly like or dislike about it. Use your opinion to learn from your work each time so that with each subsequent painting, you will hopefully improve. It's amazing how isolating a part of the picture that you really like, although you don't really like the picture as a whole, can be used to create a little painting in its own right.

Here, I have isolated the church with a card mount to make a pleasing, secondary painting.

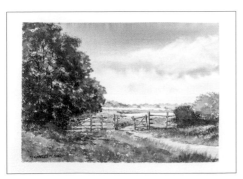

There is a lot of peripheral detail in this painting, so the eye may struggle to settle on where the focus is intended to be.

Here, I have obscured most of the tree with the mount to make more of, and focus upon, the gate.

74. I don't know whether or not to varnish my completed painting

Watercolour pictures are never varnished, as varnish is likely to disturb the paint. To protect a watercolour painting, it must be framed behind glass (see opposite). This can be reflective or non-reflective according to your taste.

If you do varnish your watercolour, you'll notice the detrimental effects, the most obvious of which is that varnish will fade the colour – the paper surface sucks up the varnish, so your watercolour will no longer gleam.

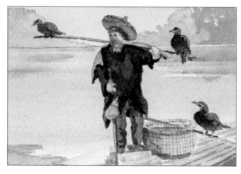

This painting has not been varnished: notice the gleam on the surface and the strength of the colours.

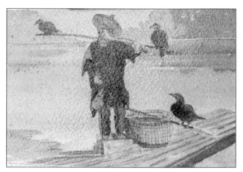

Varnish has been applied, and already the colours are looking duller.

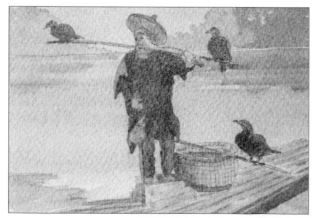

The varnish has dried, and has spoiled the impact of the painting.

75. I'm not sure whether or not I need glass when I frame my painting

Glass will prevent dirt and moisture from contaminating your watercolour painting – just remember to keep the glass clean!

I would always, but always, take a painting that you are pleased with and want framing, to a professional framer. You have put so much work into it and you're pleased with it, so show your work the respect it deserves. The job of a framer is as much an art form as the job of a painter.